Beyond
Necessity
ART
In The
Folk Tradition

❧

Kenneth L. Ames

AN EXHIBITION
FROM THE COLLECTIONS OF WINTERTHUR MUSEUM
AT THE BRANDYWINE RIVER MUSEUM
CHADDS FORD, PENNSYLVANIA
17 SEPTEMBER—16 NOVEMBER 1977

The Winterthur Museum

DISTRIBUTED BY W. W. NORTON & COMPANY, INC.

THE EXHIBITION AND CATALOGUE ARE SUPPORTED

BY GRANTS FROM THE NATIONAL ENDOWMENT FOR THE ARTS

AND THE DELAWARE ARTS COUNCIL

COVER ILLUSTRATION: Detail of a cutwork *Taufschein* (Cat. no. 194)

CONTENTS

PREFACE

THIS BOOK is part of a four-fold approach to the subject of
American folk art. In conjunction with the Brandywine River
Museum, the Henry Francis du Pont Winterthur Museum
sponsored an exhibition from September 10 through Novem-
ber 16, 1977, of more than two hundred objects never before
exhibited outside the Winterthur Museum. Since Winterthur
has no space for changing exhibitions and the Brandywine
River Museum usually exhibits paintings rather than furni-
ture and decorative objects, the institutions viewed the exhibi-
tion as an ideal way for each to do something it had not done
before. For nearly two years staff members worked together,
under the leadership of Scott Swank, head of Winterthur's
Education Division, to develop the exhibition as a new form
of outreach for each institution.

In most exhibitions American folk art is displayed aesthet-
ically, separated from its cultural context, so the staffs of the
sponsoring museums decided to explore America's folk tradi-
tions by setting the objects into various cultural contexts.

The complex and lengthy preparation of the exhibition
and its catalogue involved a great many people. Coordinators
of the exhibition were Donald L. Fennimore and Elaine Eff of
the Winterthur Museum and Anne Mayer and Joan Gorman
of the Brandywine River Museum. Susan Strickler, John
Melody, John Groff, Scott Swank, and Nancy Goyne Evans
of Winterthur also served on the exhibition committee. The
exhibition reflected prevailing notions about what constitutes
folk art, and it was mounted at the Brandywine River Muse-
um in settings skillfully designed by Vincent Ciulla.

In this book, which is the second of the four approaches to
folk art, Kenneth Ames, teaching associate at the Winterthur
Museum, looks not only at the objects and their cultural con-
text, but he also traces the historical evolution of what he calls
the folk art movement and its rhetoric. In a brilliant and pro-
vocative essay, he presents an analysis and critique of the
various schools of thought about folk art, its meaning and its

makers. In the spirit of Constance Rourke's pioneering work in 1942, he takes a historical and anthropological approach to culture, not separating art or fact from artifact, nor separating text from context but instead doing what Professor Rourke suggested needed doing—looking at the whole cultural configuration, "with its special tenacities, currents of thought, contagions of feeling, its dominant arts, whether these are polite or impolite, practical or impractical, whether they slip over surfaces in transitory popular forms or become rooted as patterns of the folk imagination or, more broadly, of the social imagination."

The third approach to folk art was the 1977 Winterthur Conference on American Folk Art, with Dr. Swank as chairman. As Dr. Ames points out, there has long been a breach between the folk art movement and the scholarly community, between the collectors, dealers, and museum personnel who display objects called folk and staff members of universities, historical agencies, and anthropological museums who take an ethnographical or historical approach to material culture. University scholars, museum directors, collectors, and specialists in folk art, folklore, and material culture analyzed the traditional view of folk art and discussed new approaches to that fascinating subject.

The 1977 Conference Report published under the title *American Folk Art* will be the final contribution of this fourfold approach to folk art—exhibition, essay and catalogue, conference, and conference report.

For the Winterthur Museum, the cooperative exhibition at the Brandywine River Museum was part of a new outreach program designed to make its collections more widely accessible to the interested public. For the Brandywine River Museum, it was a special opportunity to utilize the galaries of its renovated nineteenth-century grist mill to exhibit an important American collection, the decorative products of art in the folk tradition.

James Morton Smith, Director
The Henry Francis du Pont Winterthur Museum

James H. Duff, Director
Brandywine River Museum

ĀCKNOWLEDGMENTS

MANY PEOPLE ASSISTED ME WITH THIS PROJECT. First I should thank the students in my graduate seminar on folk art who helped formulate the ideas set forth here. As is always the case when one teaches, student comments and suggestions have imperceptibly become part of the teacher's own thinking and credit for this essay should be shared with: Shirley Brabner, Ellen Denker, Deborah Dulong, Jean Gilmore, John Groff, Peter Hammell, Kathleen Johnson, Neil Kamil, Rebecca Lehman, Sandra Mackenzie, Donna Rosenstein, Hope Schladen, June Sprigg, Robert St. George, and Donald Stover.

Others helped in more specific ways. Ellen Denker untiringly helped locate information and also read the manuscript in its early stages. Deborah Waters prepared the annotated bibliography. Elaine Eff and my colleagues Benno Forman, Joseph Hammond, and Scott Swank offered encouragement and suggestions. Kay Keenze typed more drafts of the manuscript than anyone should have had to and still retained enough energy and humor to get us both through. Catherine Hutchins edited the essay with sensitivity and tact, reducing it from a rambling soliloquy of much greater length to its final form and improving it considerably in the process. She also deftly and capably coordinated all aspects of this publication. John Anderson deserves credit for the book's handsome design.

Special thanks go to Henry Glassie, Michael Owen Jones, and James Loewen. Reading their books and talking with them have helped me immensely in this essay. As authors habitually point out, they deserve recognition for much of whatever may seem useful here. I take full responsibility for any and all faults and hope they will not feel that I have distorted or misrepresented their work.

Finally, I must thank my wife, Gail. She not only took time away from her own demanding work to help edit the manuscript but listened patiently over several months as the essay evolved and helped steer me away from untenable or illogical positions. Of all contributions, hers has been the greatest. Whatever sense this book may make is traceable to her influence.

Kenneth L. Ames

INTRODUCTION

IN 1975 THE WINTERTHUR MUSEUM decided to sponsor both an exhibition and a publication devoted to folk art. From the outset we realized that there were two ways of dealing with this popular phenomenon. We could participate in it or we could analyze it. We decided to do both.

This publication supplements an exhibition designed to respond to the public enthusiasm for folk art by making part of the extensive holdings of the museum better known to people interested in the subject. Staff members and consultants from other institutions concurred that although Winterthur's folk art holdings had not actually been ignored, they had played second fiddle to the artifacts of the affluent for which the museum is more widely known. The goal was to put on public view a sampling of these objects with the hope that their display would encourage further study of folk artifacts, generate new questions, and open new areas for investigation, as well as call attention to Winterthur's large collection of folk art.

Objects were selected for exhibition on the basis of their correspondence to prevailing contemporary notions about what constitutes folk art. Most of these items had come to Winterthur during the lifetime of Henry Francis du Pont. Like the more formal furnishings for which the museum is known, they are a tribute to his taste and perseverence. Mr. du Pont was neither a historian nor a theoretician but a collector with a highly developed sensitivity to the visual values of his age. The collection therefore bears his imprint but also reflects the collecting tendencies of his day. This can be seen with particular clarity in the type and range of artifacts called folk art.

The exhibition illustrates what is generally meant by folk art and provides a sumptuous feast for the eyes. The publication, on the other hand, attempts to look at folk art in a dispassionate, detached way. It is clear that the folk art phenomenon corresponds to important social and artistic changes in the last two centuries and that from historical, sociological, and

psychological points of view, the movement and its rhetoric are every bit as interesting as the objects themselves. The fascination with folk art may be linked to the general shift in values in the western world since the eighteenth century. Because the age of absolute monarchs and inherited titles has given way to the age of the common man, it seems appropriate to devote attention to objects that were part of the daily life of the many rather than of the few. It makes sense to provide people in the twentieth century with a more balanced view of the artifactual world of the past. Today's reverence for egalitarianism and democracy calls for an unprejudiced look at artifacts from the past to give the inarticulate majority and other unsung and uncelebrated people an honest and unbiased hearing.

If this is what the interest in folk art is all about, it can be related to recent developments in the discipline of history, variously described as the new history, history from the bottom up, folk history, popular history, nonelite history, and the underside of history. These new approaches attempt to balance the annals of history, for an understanding of the past and how the present grew from it cannot emerge from studies limited to a few outstanding figures or monuments; accurate generalizations about earlier societies or cultures cannot rely upon skewed samples. To better understand the past and the present it is necessary to study the ordinary and typical, not just the extraordinary and unique.

It would seem that folk art should be the material culture component of the "new" history. Yet this is not the case; despite its beguiling name, folk art has not attracted the "new" historians, nor the folklorists, who presumably should flock to it. The uneasy fact is that folk art has been ignored by exactly the people who might embrace it with the most enthusiasm. This raises a central issue: Is folk *art* really *folk* art? It is this riddle which provides the rationale for another publication about folk art. It provides the opportunity to explore the concept of folk art, to look at its definitions, its history, and its meaning for people today. We have only scratched the surface in our attempts to comprehend this remarkable popular phenomenon. This small volume is offered as a contribution toward an understanding of what has come to be called folk art.

12

THE PARADOX OF FOLK ART

WHAT IS FOLK ART? is an easy question to ask but a difficult one to answer. Part of the problem stems from the term itself, for each word is hard to define. Not only are the denotated meanings many and varied but both *folk* and *art* are surrounded by a magnetic field of connotations and associations. They are charged with meaning; Oliver Wendell Holmes would have called them polarized words.[1] When combined they communicate, but they also conflict. Some of their meanings and associations are so incompatible that the term becomes a paradox: *folk* cannot modify *art*. Without getting lost in the maze of semantics, let us try to determine what *folk art* means, starting with an examination of the two words and the concepts they signify.

The notion of folk has a long history and variant meanings. Europeans have often used the word with nationalistic overtones referring to a native or inborn genius of a people.[2] Americans have followed that course or adopted a Darwinian (phylogenetic) view of mankind in which folk is associated with an early stage of human social development. A present day manifestation of folk is explained as a kind of living past, an unusual survival of ancient ways. One well-known American formulation of folk appeared in the writings of Robert Redfield, who roughly equated folk with primitive.[3] The prototypical folk society he described existed before the rise of cities or remains unaffected by major civilizations. His characteristic folk society is small, isolated, and internally cohesive. People within it share the same ways of doing things. They intermarry, have a strong sense of group identity, and believe their own ways superior to those of others. In a folk society there is little specialization; knowledge is shared. Interactions are patterned largely by kinship, status, and role. In sum, these societies are marked by isolation, smallness, homogeneity, and a shared view of the good life.

While Redfield's model may be historically and anthropologically accurate in early European, Asian, or African societies, it

is of limited use when dealing with what is called American folk art, most of which is the product of the eighteenth and nineteenth, and, in some cases, twentieth centuries. The Redfield model conforms poorly to what is known of early American society and becomes even less relevant for the later periods.

Henry Glassie, one of today's most productive and provocative scholars, has proposed a different definition of folk which is commendable for its utility and simplicity. For Glassie, *folk* is a relative term which identifies a conservative cultural orientation.[4] Items which are folk are traditional and perceived as such by people who make them or use them. What is accepted as traditional changes with time, and objects once considered innovative that are retained without significant change may eventually be considered folk. However, Glassie also makes it clear that the term *folk* does not include all kinds of traditional behaviors or materials. It does not, for example, include products of elite society. That is, while folklorists might study old-fashioned ways of preparing food or making quilts in Appalachia, they do not usually study the equally venerable traditions among the affluent. They are not interested in upper class modes of dress or speech, dining habits, use of leisure time, political inclinations, or interactions with servants, although these may derive from yet older traditions. For folk is tradition from the bottom up.

These two concepts of folk reflect different scholarly orientations and needs. Redfield's concept is based on anthropological documentation of surviving nonliterate primitive societies and the archaeological remnants of past cultures. Glassie's concept is based upon the survival of tradition in diverse societies but includes a built-in provision for change within that tradition. The Redfield concept is an attempt to classify social organization and emphasizes the people and their society. Glassie focuses on material culture and stresses the artifacts used by a society. His definition allows the material culturalist to deal with the multifaceted nature of human beings, for experience has shown that an individual may utilize a traditional or conservative artifact in one context but employ a modern or progressive artifact in another. This happens to-

day: contemporary consumption patterns often reveal a variety of cultural levels.

The recognition of cultural levels is where folk becomes a charged word. Those who identify folk with primitive imply a degree of inferiority. The association suggests a society that has been made obsolete by newer and better ones. This makes it easy to view folk objects as inferior to those of the dominant society and to see people called folk as somehow *less:* less sophisticated, less complex, less developed, less accomplished, and perhaps less human as well. This, in part, explains the air of condescension that marks and mars much written about folk art.

The other polarized word, as Holmes called it, is *art*, which has a wide range of meanings. On one level, art denotes a certain skill or dexterity in doing almost anything. Yet in other contexts art has a more specific meaning. One has certain expectations from an art history course. Art in this instance is confined to painting, architecture, sculpture—and occasional examples of the so-called decorative arts—all associated with certain elite cultures.

Some of the connotative charge of art stems from its elevated position in Greek and Roman antiquity and the Italian Renaissance, civilizations which are seen as pinnacles of human achievement. From the former came a canon of aesthetic values which is still influential; from the latter an ineradicable association of art with wealth, power, and status. The Renaissance is dead but still influences art scholarship and the teaching of art history. It remains the core of many art history programs, and Giorgio Vasari's cult of the artistic personality and celebration of innovation still color writing about art four hundred years later. In a sense, to be an artist means to labor in the tradition of Leonardo, Michelangelo, and Raphael and to bask in the glow of veneration that still surrounds them. *Art* is bound by unseen chains to a vast heritage of values and associations which elevate and ennoble the exceptional object and its maker.

The concepts of folk outlined by both Redfield and Glassie are incongruous with the Renaissance conception of art. Redfield's nonspecialized folk society does not produce full-

15

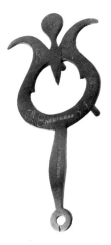

Fig. 1. *Trivet,
attributed to James
Sellers. Philadelphia,
dated 1837. Wrought
iron; L. 30.3 cm.
60.788*

Fig. 2. *"Suffolk latch"
door handle. Vergennes,
Vt., dated 1820.
Wrought iron, punch
decoration of masonic
symbols; H. 47.6 cm.
52.11*

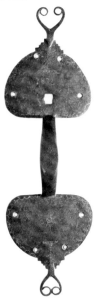

time artists and Glassie's emphasis on tradition contradicts the celebration of innovation. One solution to this impasse is to reject both Redfield's and Glassie's definitions of folk. A preferable, if radical, solution is to eliminate the restrictive associational definitions of art. In a concise and suggestive little volume, *The Shape of Time*, George Kubler argues in favor of expanding the concept of art to include all man-made objects.[5] This is doubly salubrious. First, it puts all the artifactual world on an equal footing by abolishing arbitrary ranks. Secondly, it does away with the problem of having to distinguish art from non-art, thus providing a welcome release from a persistent compulsion that has diverted energy from more productive investigations. The generations of scholars who have tried to seize and elucidate those special qualities of an object which make it a work of art have been largely unsuccessful. It is time to admit that art is not an eternal truth but a time-linked and socially variable concept, its definition being altered in response to complex patterns of social interaction.

Students of all aspects of material culture need to pursue historical questions without becoming bogged down in the usually irrelevant issue of artistic merit. This is not to say that the concept of art is insignificant or unworthy of investigation; on the contrary, there are many reasons to study why some objects are called art, what particular artifacts are so designated, and how the social organizations which surround them function. In short, art should be studied as a historical and sociological phenomenon. It is intellectually irresponsible to continue to unreflectively confer the honorary degree of art on a small segment of the artifactual world of the past, blithely ignoring most of the surviving artifacts because they do not measure up to an unstated but implicit canon of acceptability.

When scrutinized under good light, acceptability seems to savor more of Mammon, the marketplace, and subtle social conflict than one might have expected. Students of art have long exhibited a subjective preference for "the striking, innovative, or otherwise noteworthy design" in which "an extravagant, not an optimum, investment of blood (skilled workmanship) and treasure (materials) is evident."[6] Behind their preference has been the still-enduring notion that art is really something for the aristocracy.

16

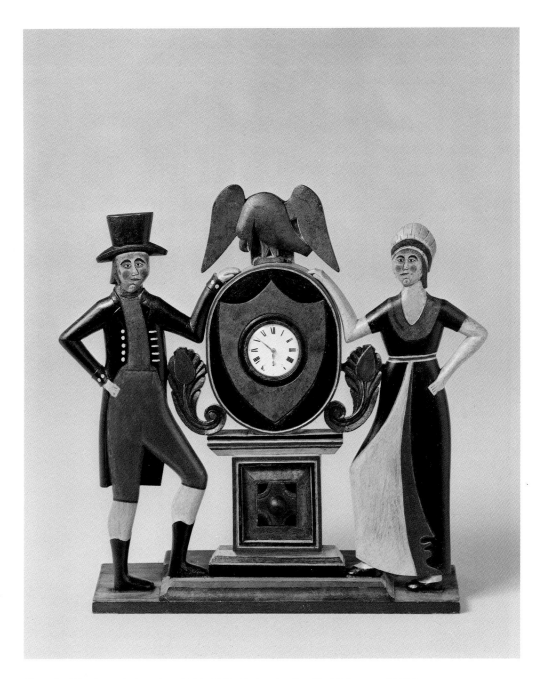

Plate I. *Watchstand, America, 1800-1900. Painted tulip; H. 37.5 cm. 67.827*

Fig. 3. *Rachet-type trammel, America, 1700-1800. Wrought iron, punch decorated; L. (min.) 126.7 cm., (max.) 172.1 cm. The most complex and difficult to operate of three known types. Other types did the same job more efficiently. 65.2842*

Conventional wisdom is useful on this point. Folklorist Michael Owen Jones asked several "folk" about art.[7] Most of his respondents saw it as something remote and apart from their lives. Art was mostly paintings in museums rather than the kinds of objects they possessed or saw regularly. Although they did not say so, these people might have agreed that art was something for the elite. They did not think of art as part of their lives even though they owned objects that they regarded as special and that provided them with pleasure and satisfaction. Their testimony reinforces the need to study the concept of art as a historical and social phenomenon and to look afresh at the artifactual world.

For historians there is more to be gained by ignoring the arbitrary boundaries of art than there is to be lost by observing them. The differences between objects considered folk art and those with no loftier designation than just "things" have been exaggerated. On any desk one might find a pencil sharpener, a box of paper clips, a paper punch, or a pair of scissors. Objects like these, usually considered unworthy of much attention, can be discussed in the same terms usually reserved for objects identified as art. A cast-iron trivet marked by J. Sellers of Philadelphia and dated 1837 (Fig. 1), a door latch removed from the first Masonic Temple in Vergennes, Vermont, that is dated 1820 (Fig. 2), an eighteenth-century iron trammel (Fig. 3), and an iron toaster with twist decoration (Fig. 4) may be more valuable to collectors, but in every other way the eight objects are quite similar. Each is the result of a series of mental and manual processes; each represents the externalization of a mental structure. In short, each has been designed, as have been all of man's objects.[8] And studying the *designed* world is a way of escaping the pitfalls of studying only art.

The art approach has other drawbacks. Jones cogently argues that scholarship which has approached the artifact through the portal of art has led to a gross oversimplification of the role of art in other cultures as well as in our own. He presents an impressive array of arguments and concludes that the best way to learn about art is to set aside the term and simply study the things people make and do in daily life.[9] The advantages of this approach are twofold. First, it is an admis-

18

Fig. 4. *Toaster, America, 1750-1800. Wrought iron;
L. 80 cm. 66.527*

sion that connotations of art get in the way of an unbiased study
of artifacts. Jones accordingly titled his work *The Hand Made
Object and Its Maker* to stay clear of the alluring but debilitating
business of art. Secondly, working outside the traditional
concept of art allows one to escape from the accompanying
need to judge and evaluate. The air is cleared for a discussion
of folk artifacts or material culture from vantage points which
are more relevant to the original context of the object.

It is legitimate to ask if this discussion of cultural and aesthet-
ic biases is necessary. Do these things really matter? If judg-
ments were made only about objects and went no further, the
answer would probably be no. But judgments about objects
often extend to people. Describing objects as ugly, tacky, or
kitsch is actually deprecating their makers or users. And this is
a more serious matter. The folk art movement has been
cavalier about the people associated with objects. On one hand,
it has often removed objects completely from a societal context
which, in effect, has deprived them of any identification with
humanity. On the other, when context has been provided, it
has been falsified and distorted.[10]

In the value system of many of the people who have been
active promoters of folk art, art outranks history. In the major-
ity of recent exhibitions, there has been little inclination to
place objects in historical context. In fact, the opposite has been
the case. Emphasis is usually on what is described as the artistic
merit of individual pieces rather than on what are condescend-
ingly called "their historical associations." As explained in a
recent catalogue, "Objects are not presented chronologically
or grouped according to type, but installed so that each item
has sufficient space to be enjoyed as a work of art in its own
right."[11] Deprived of historical context, an object becomes art.
In other words, by severing fact from artifact, one can "make"
art.

From one point of view, the enthusiastic "art in its own right"
approach is beneficial. It effectively illustrates the contention
that all that man has made is worth looking at. But it also

19

Fig. 5. *Miniature cradle, chair, dresser, table, bench, chest, Pennsylvania, two pieces dated 1803. Red earthenware, incised decoration, clear lead glaze; H. (of dresser) 7.5 cm. The initials or name of the probable owner, Sophia Jacobs, occur on three pieces. 64.1720. 1-6*

encourages writers to project their own emotions and sentiments onto the object. One could do this for a carved figure of a woman (Fig. 6) about which little is known. It was reportedly used as a counter figure in a general store in Tremont, Pennsylvania, but how it functioned is only conjecture. Freudians might associate it with images of the great mother and issue a profound statement about the eternal and mystifying allure that woman holds for man. Social historians might focus on the reddish color of the figure's skin and write a scathing commentary on the plight of native Americans. Art historians might note the similarity of the figure to the snake goddesses of ancient Crete and stress the satanic side of sexuality. But most of this projection does little to explain what the object meant to its maker or original owner. Considered as a piece of folk art this mysterious carved figure does illustrate nicely one belief apparently shared by many people involved with folk art: "Representative objects are boring; *objets d'art* are thrilling."[12]

The rise of the fascination with folk art and its relation to the alteration of aesthetic values fostered by progressive art of the twentieth century has been traced by Daniel Robbins in "Folk Sculpture Without Folk."[13] Folk art writers and collectors, emulating Marcel Duchamp's "ready-mades" (but lacking his wit or humor), have set out to parade their own creativity by

Fig. 6. *A native woman, Pennsylvania, 1850-1900. Painted tulip; H. 51.4 cm. Used as a counter figure in a general store in Tremont, Pennsylvania 65.2194*

finding art in unconventional places. Robbins argues that people in the twentieth century have come to believe that one does not have to *make* anything to be an artist; one can create art merely by discovering it. The extent to which this occurs is an indication of one's own sensitivity and imagination. The emphasis on aesthetics combined with the elimination of context as a step in the apotheosis of an object to the status of art severely hinders the historian's attempt to explore the artifact's place in space and time.

Even more damaging than no context, however, is falsified context, created to satisfy a priori assumptions about folk art, its meaning, and its makers. Folk art rhetoric rests upon an interwoven web of assumptions which are implicit or explicit in much of the writing on the subject, particularly that intended for a general audience. It is possible to disentangle and identify five distinct strands of this web, all of which might be termed myths: (1) the myth of individuality, (2) the myth of the poor but happy artisan, (3) the myth of handicraft, (4) the myth of a conflict-free past, and (5) the myth of national uniqueness. Some or all of these appear in the most familiar writings about folk art. Like most myths, they persist because they are socially useful and provide explanations that people find comfortable and reassuring. They also endure because there has been little sustained attempt to determine to what extent they are rooted in fact. Many of the authors freely hypothesize about the past, and their tendency to wrench objects from context makes it easy to avoid confronting the myths with data which might undermine them. Thus, exhibitions filled with atypical objects made sometime in the nineteenth century for unknown purposes by anonymous artisans living in an undetermined northeastern state can provide the basis for a mythologizing argument so amorphous that it is difficult to refute. It can be argued that the rhetoric of folk art and the persistance of idyllic escapist myths have warped the perception of the past and, hence, of the present as well. Folk art enthusiasts have created a communal fantasy world that distorts the integrity of both the objects and the people originally associated with them. One can get a fuller sense of how this operates by examining each of these myths.

21

Fig. 7. *Shirred rug, probably New England, 1875-1925. Wool surface, cotton backing; L. 175.2 cm. 69.1949*

INDIVIDUALITY

One of the most pervasive myths supports the notion that individuality is the folk artists' outstanding characteristic. The people who assemble the folk art collections and exhibitions certainly have enhanced this myth by emphasizing uniqueness. Since they perceive the objects as atypical, their logic suggests that atypical people must have made them. The interpretation of uniqueness is augmented by the "sampler" approach to display where objects are isolated as monadnocks of human genius. But this is misleading. When placed in historical and artifactual contexts, these objects become part of a broader terrain shaped by a multitude of complex interrelated forces. Rather than unique, they are similar to many, and in some cases, thousands, of other objects.

Robert Trent, in a brilliant study entitled *Hearts & Crowns,* has dismantled the part of the myth that touts an object as the expression of individuality. He assembled about seventy-five chairs from the Connecticut shore, the majority anonymously made, and explained their chronological relationships and the effects of varying influences upon their final execution and form. Seen in a group, no one chair looked unique. They were

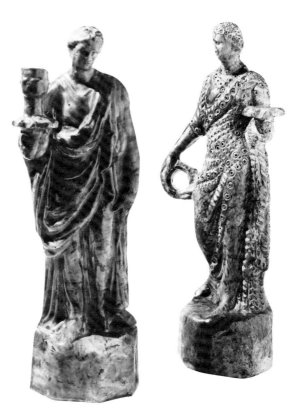

Fig. 8. *Figures with candleholders, attributed to Richard Franklin Bell. Strasburg, Virginia, 1885-1890. Red earthenware, mottled lead glaze; H. 39.4 cm., 40 cm. Each is one of a pair. Figure on right is stamped "S. Bell & Son/Strasburg" and was supposedly made by R.F. Bell as a wedding gift in 1889. 67.1627,.1626*

all similar. The distinctive qualities of some could be explained by changing conditions of time and place. This approach made it possible to see that although each chair was the product of a series of decisions made in one shop, these decisions were related to and affected by solutions reached in other shops. The typical folk art approach paints an appealing picture of the inventive powers of the human mind, but it contradicts what is known about the mind's processes and possibilities. Trent's innovative study suggests how scholars might begin to explore what takes place in the mind when people design and construct objects.[14]

The myth of individuality extends beyond the artisans who constructed chairs and other objects to the *folk*. The concept of individuality, which stresses free will and unlimited personal choice, must be approached with caution, for it is something of a sacred cow. It is a part of both the mythology of folk art and the mythology of America and is an important element in the

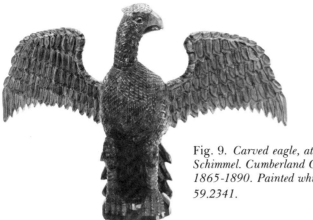

Fig. 9. *Carved eagle, attributed to Wilhelm Schimmel. Cumberland County, Pennsylvania, 1865-1890. Painted white pine, H. 60.3 cm. 59.2341.*

romantic ideology of the nineteenth century. Although the logic is clearly circular, the belief in individuality supports and stems from a historical interpretation of the past as a period in which free will was paramount. Recent examinations of human behavior have demonstrated that despite the existence of differences between people, individuality and free will have been exaggerated. A remarkably narrow operational range and limited options are available even to those who make the greatest effort to distinguish themselves. In behavior, motivations, and development, people tend to be more alike than different.[15] The myth of individuality has disguised this sobering, intimidating reality and made it possible to see the exceptional, even when not there. The alleged individuality of the folk, as expressed by the folk artist, has raised the question, Why is society no longer made up of strong, forceful, independent individuals? The answer becomes self-evident: The past was superior and society has lost its moral fibre and gone into a decline.

The folk art propagandist's paean to individuality does not stand up under scrutiny. The easiest and best test is to look at

Fig. 10. *Detail of Taufschein of Cornelius Dotter, Chestnut Hill Township, Northampton County, Pennsylvania, ca. 1826. Watercolor and ink Fraktur; H. 39.4 cm. 61.1105*

24

the material on which it is based. *The Flowering of American Folk Art* provides a concise survey of images. Despite the attempt to emphasize the uniqueness of folk art, repetition is more striking than innovation; similarity outweighs diversity. Like all human behavior, the folk artist's approach to the subject and the manipulation of materials are patterned. The variety of surfaces and subjects does not obscure the fact that the designs are products of similar cerebral processes.

Individuality can be interpreted in more than one way, of course. Consider Wilhelm Schimmel. The Schimmel eagles are particularly well-known (Fig. 9), although Schimmel cannot have carved all that are attributed to him. These birds have a certain distinctive quality in their economical approximation of form and lively texture and color patterns which might be called individuality. However, they were not generated from a void. Ample artifactual antecedents can be found in the carving tradition which Schimmel probably learned in his native Germany, and in coins, prints, and other visual materials current in the German and dominant Anglo-American cultures of nineteenth-century Pennsylvania (Fig. 10).[16] In the process of carving, Schimmel displayed neither more nor less individuality than did his contemporary, Eastman Johnson, painter for the wealthy. Most Johnson paintings, like Schimmel carvings, are recognizable because of the distinctive assemblage of traits called personal style. Neither is necessarily superior to the other but they are decidedly different. While the works of both are usually included in surveys, Johnson's in nineteenth-century painting and Schimmel's in folk art, Johnson has been the focus of sophisticated modern scholarship while Schimmel, except for a solitary article written nearly thirty-five years ago, has been largely ignored.[17] Perhaps because so much is known about the painting context in which Johnson and other prominent painters worked, some writers can maintain that their works lack individuality. But if scholars spent as much time reconstructing the artifactual context of Schimmel's work, they might discover that his achievement and his innovation were just as dependent upon other people and their work. In short, people who make things probably have much in common.

Another way to define individuality is as bizarre or deviant

25

behavior. When seeking a prototypical folk artist, folk art specialists often look for the strangest person they can find. Although Michael Owen Jones was not mythologizing in *The Hand Made Object and Its Maker,* his choice of an eccentric individual fits folk art expectations about the creative person. The man Jones chose was a colorful and quixotic character called Charley, a chairmaker in rural Kentucky. Charley was as folksy as one can get. Not only did he live in a state known to be full of folks, but he was nearly illiterate, had difficulty interacting with others, and suffered through an unsatisfactory marriage and a wretched home life. Appropriately enough, he wandered around barefoot, wore blue denim overalls, let his beard grow long and shaggy, and composed a musical ditty entitled "My Old Kentucky Mountain Home." If this is individuality, Charley had plenty of it. So did Wilhelm Schimmel. Schimmel was a loner, an outcast, and an alcoholic. He frightened and alienated the people around him with his erratic and irrational behavior. He was a marginal man, living at the edge of society.

The type of personality exhibited by Charley and Schimmel is not characteristic of any folk society anthropologists or folklorists have studied, but it is congruent with certain expectations about artists. Although the tradition of the unconventional artist can be traced at least as far back as the eccentrics Vasari described, it was strengthened in the last century by romantic notions of individuality and creativity and by the unorthodox behavior of people like Vincent van Gogh, Paul Gauguin, and Edvard Munch. Artists are expected to be different; some theorists hold that a certain degree of alienation fires the creative spirit.[18] Whether or not this is true, it is clear that neither Charley nor Schimmel are representative exponents of any folk society. Because they were rejected by their peers, the claim of similarities between folk artists and the people they worked for does not hold up. Charley and Schimmel may provide useful insights into alienation and creativity but they are not typical of any society but are social outcasts.

The last problem with the idea of individuality is that it simply does not conform to the understanding of folk societies. If anything, folk societies are conformist and repressive. Be-

Fig. 11. *Jug. attributed to Frederick Carpenter. Charlestown, Massachusetts, 1804-13. Buff stoneware, cobalt-filled incised decoration, brown slip interior, salt glaze; H. 28.5 cm. Carpenter apparently used the Boston stamp for wares to be sold at the Boston shop of his benefactor, William Little.* 55.61.8

cause they are homogeneous, unified social organizations rather than diversified, pluralistic societies, they display less tolerance for deviant or exceptional behavior. Charley and Schimmel, although they may be revered by folk art enthusiasts, were both social outcasts.

THE POOR BUT HAPPY ARTISAN

The second pervasive belief presumes the folk found personal fulfillment in their tasks: "We know the creators of these things, though they worked hard, enjoyed every minute of it."[19] There may be some truth to this as for all of the myths, since a myth must have some degree of plausibility to be acceptable. The problem lies as always in generalizing about all instances from a few examples which may not be typical. Consider the carver Schimmel once again. He was an outcast, a wanderer, a drunkard. He had no home, no family, and few friends. He slept in barns and jails and died a pauper in the Carlisle, Pennsylvania, almshouse.[20] By twentieth-century standards he probably would have been declared insane and confined to an institution. Surely it is distortion to claim that he loved every moment of carving. It might be more correct to say that his carving provided an escape from a world with which he could not cope, that it allowed him to become immersed in an activity of which he was the master and which granted him a

Fig. 12. *Basket decorated by Anna Maria Osmond. Chester County, Pennsylvania, or Kent County, Delaware, 1860-80. Tinned sheet iron, painted; L. 17.1 cm. 59.2031*

degree of stability and release from the emotional stress and confusion with which he apparently struggled. To say that this troubled and tormented man "enjoyed every minute of" his work is not only misleading, it is condescending, too. But condescension is no stranger to the writers of folk art, who prefer to depict Schimmel as "a picturesque itinerant."[21]

A few details of Schimmel's life are known because he attracted attention, or perhaps notoriety. Much less is known about many of the other people who made what is called folk art but there is no particular reason to believe that a decorator in a pottery in Charlestown (Fig. 11) or Bennington reveled in decorating stoneware jugs with cobalt, or the women painting tinned sheet-iron goods enjoyed repeating the same flowers, the same borders, and the same handle decorations month after month (Fig. 12, Pl. II), or the travels of an itinerant painter contained one delightful episode after another. It is equally fallacious to reason that jubilant designs on a bed rug (Fig. 13) and a jacquard coverlet reflect the jubilance of the needleworker and weaver at work. Such notions are based on a lack of sensitivity to the realities of work. In the process of making things there are two phases which may generate some delight for the maker. The first is when an idea or a solution to

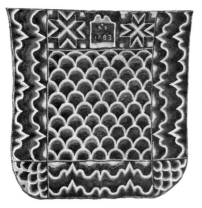

Fig. 13. *Bed rug, probably the Norwich-New London area, Connecticut, dated 1783. Wool; L. 228.6 cm. This is an unusual bed rug because the running stitches, which are normally looped, have been pulled flat. 66.604*

28

a problem is conceived. The second is when the task is completed. Between these two pleasurable moments there normally lies a good deal of just plain work.

The nature of the work varied according to the objects produced. Those objects that brought joy and happiness to the users did not necessarily elicit the same emotions from their makers. Some writers claim that the mechanization of production took the joy out of work. The real distinction, however, is not between producing objects by hand and producing them by machine. Handwork does not necessarily make labor more enjoyable. It is a matter of wanting to make objects or having to. Present-day folk art enthusiasts tend to project their enjoyment of current voluntary part-time involvement with handicraft onto an age when handwork was unavoidable. Their current dabbling in manual crafts today is pleasant partially because it is not routine but an exception. Repetitive work becomes boring, compulsory work odious.

The myth of the poor but happy artisan contains a strong dose of unreality. Indeed some who deal with folk materials seem unwilling or unable to confront reality. In a forceful and fascinating book, *Urban Blues,* Charles Keil associated this with the moldy fig approach to folklore.[22] *Moldy fig* is the term formerly used by jazzmen to refer to an individual interested only in jazz written before World War I. Although most of the original moldy figs were white scholars sitting in judgment of black music, the term is applicable to the context of folk art as well.

The moldy figs perceive the early manifestations of a genre as pure and enjoyable but later versions as decadent and unacceptable. The *real* bluesmen, who are analogous to *real* folk, must meet stringent requirements:

Old age: the performer should preferably be more than sixty years old, blind, arthritic, and toothless. Obscurity: the blues singer should not have performed in public or have made a recording in at least twenty years; among deceased bluesmen, the best seem to be those who appeared in a big city one day in the 1920s, made from four to six recordings, and then disappeared into the countryside forever. Correct tutelage: the singer should have played with or been taught

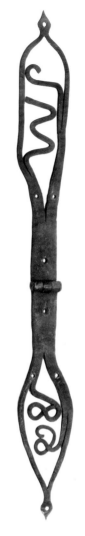

Fig. 14. *Hinge, probably Pennsylvania, dated 1800. Wrought iron; L. 97.8 cm. 69.1953*

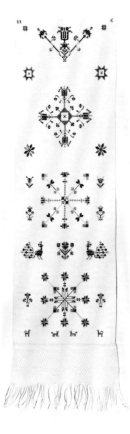

Fig. 15. *Fringed hand towel, probably Pennsylvania, 1800-1870. Linen with cross stitch embroidery; L. 123.2 cm. 69.1164*

by some legendary figure. Agrarian milieu: a bluesman should have lived the bulk of his life as a sharecropper, coaxing mules and picking cotton, uncontaminated by city influences.[23]

Despite the humorous exaggeration and hyperbole of this description, it is not too far from the situation of a decade or two ago and is still true of some prominent programs established to document folk music. Instead of analyzing the readily accessible remnants of tradition around them, today's moldy figs search the Deep South, Appalachia, or the Canadian Maritimes for obscure figures who fit as many of these characteristics as possible. The youthful, prominent, and successful folk musicians are unacceptable and their music diluted, crude, and corrupt.

The ancient bluesman is akin to J.-J. Rousseau's noble savage. His shortcomings and misfortunes are transformed into virtues and blessings. The same mentality makes Schimmel a "picturesque itinerant." He is both less and more. He has not been financially successful because he has remained uncorrupted by the world's materialism and is above financial considerations. He makes or does things solely for his own enjoyment. This approach obviously presents great difficulty when folklorists must reconcile the idea of folk with the reality of material success.

Most moldy figs folklorists sidestep the issue of material success by concentrating their efforts to find the poor but happy folk in remote rural settings. Were they interested in tradition, per se, they would examine urban ghettos, ethnic enclaves, and the neighborhoods encircling the urban campuses.

Admittedly the need for academic respectability has sustained the moldy fig approach. The folk specialist who studies earlier folklore or present folk as a kind of living past hopes to attain a degree of respect often not accorded those who attempt to study or explain today's society.[24] Henry James once pointed out that things very ancient never appear vulgar. Age hallows; it brings respect. Time transforms the trivial into legitimate subjects for serious research.

Finally, the myth of the poor but happy artisan absolves

Fig. 16. *Hooked rug, probably New England, 1870-1925. Cotton and wool on burlap; L. 228 cm. 64.804*

feelings of guilt. If the poor can be happy making folk art, one need not feel obliged to change their situation or apologize for it. In fact, it is those other poor people today who must justify themselves and explain why they refuse to be happy making folk art the way their ancestors were.

HANDICRAFT

Another of the myths making up the web of folk art ideology is the belief that the objects which comprise this category have been fabricated by hand and are therefore superior. No machine, no inhuman intruder, no aspect of the industrialization which has darkened the world and our hopes and dreams, taints the creations of the folk. This myth, like the others, has a limited basis in fact. Totally mechanized production is a relatively recent development which in some parts of the world has still not struck with much force. It is natural and appropriate that the study of tradition concentrates upon the retention and

3 1

perpetuation of hand methods of production. The problem lies in an oversimplified diagram of cause and effect. The machine and industrialization have been made the scapegoat for concurrent social ills.

The tendency to blame the machine for complex social problems can be traced back well into the last century, but there are obvious difficulties with the argument. Chief among them is the inescapable fact that much of the amelioration of physical conditions is attributable to the accomplishments of machines and their ability to reduce human labor and the cost of material goods. It is difficult to deny that society has benefitted from mechanization. In fact, it is doubtful that anyone would take seriously the claim that industrialization is responsible for current social problems. As historian Lewis Mumford wryly pointed out years ago, people are responsible for social problems; machines are neutral.[25]

The fact that most people do not labor manually day in, day out, year after year, feeds the myth of handicraft. Recently, one writer blithely explained that in American folk societies "each man personally shapes his own environment with his own hands."[26] This is a noble concept but, if taken literally, can be only a utopian dream. Unless basic needs are somehow provided for, each man lacks the time, energy, and resources to shape much of his own environment. Indeed, were this

Fig. 17. *Coffeepot with punched decoration, Willoughby Shade. Philadelphia, ca. 1865. Tinned sheet iron; H. 28.2 cm. Made for Catharenah Moyer.* 65.2152

32

Fig. 18. *Weathervane, America, 1800-1900.*
Sheet iron, wrought iron, originally gilded;
H. 69.8 cm. 57.112

romantic view reversed and every person restricted to only
what he could make, a bleak and austere world would result. It
is elaborate social organization and industrialization that have
allowed people the option of escaping from the narrow, te-
dious world of hand manufacture. Machines, operating as an
extension of men's hands, work more efficiently, more power-
fully, more rapidly, more economically to produce objects that
would, if made by hand, require an unconscionable expendi-
ture of time, labor, and money.

A second problem with the myth is that not all the objects
called folk art were hand made. Metal pieces have been cast or
stamped: weathervanes in zinc, copper, or iron; containers and
trays in tinned sheet iron. Ceramic plates, vessels, and figures
have been molded and pressed. A variety of objects have been
stencil decorated. Most other objects have been produced with
the aid of highly specialized tools. On the other hand, not all
handmade items are folk art. Academic paintings and carvings
continue to be manually executed. Models and patterns for
new and sophisticated manufactures are hand fabricated.

Why people now prefer handmade objects is a complex
matter. It has not always been the case. In earlier times there
was little choice; only rudimentary mechanized techniques
were available. By the middle of the nineteenth century in-
dustrially produced objects had made much handwork obso-
lete or economically noncompetitive and a remarkable trans-
formation in taste occurred. In those years the virtue of hand-
work was eloquently pleaded by the indefatigable John Ruskin.
Later, it was argued in an urbane, chatty style by Charles Locke

33

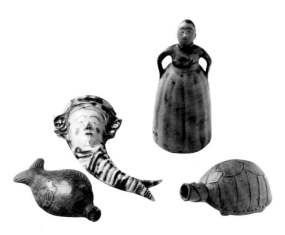

Fig. 19. *Earthenware bottles. Fish-shaped pocket bottle from a mold designed by Rudolph Christ, Salem, North Carolina, 1810-30. L. 17.1 cm. 59.2147. Turtle-shaped pocket bottle, Pennsylvania or the South, dated 1797. L. 14.7 cm. 65.2309. Mermaid-shaped flower holder, or wall pocket, possibly Pennsylvania, ca. 1850. H. 22.2 cm. 58.120.26. Woman-shaped bottle, with corked removable head, America, 1800-1900. H. 21.6 cm. 65.2008*

Fig. 20. *Locksmith's shop sign, America, 1750-1850. Sheet iron, wrought iron, originally gilded; H. 58.2 cm. 59.1801*

Eastlake in his famous book, *Hints on Household Taste* (1868). Eastlake espoused an aesthetic of "rough workmanship" and praised the imperfections and tiny flaws which are conventional marks of handwork but usually absent in mechanized production. Behind the Eastlake stance, which was both revolutionary and reactionary, was a complex set of ideas about and responses to mechanization and the industrial revolution, social reform, cultural conflict between the intelligentsia and the financially powerful nouveau riche, and the struggle between England and France for cultural supremacy. Eastlake helped popularize the straw-wrapped chianti bottle, the rustic wooden bucket, ornamental hand-wrought iron, and the asymmetries that proved an object was handmade.[27]

The ideas of Ruskin, Eastlake, and William Morris influenced the development of modern design, contributed to the vigorous revival of handicraft, and affected, at least indirectly, the folk art enthusiasts. Most of the objects categorized as folk art (even those industrially produced), manifest imperfections associated with hand production. Lorenza Fisk's genealogical sampler (Fig. 29) displays ample evidence of hand construction. The names of individual members of a specific family ornament a great tree meandering up through the center of the picture. Each fruit on the tree bears the name of a child who came from the union of Abraham and Grace Fisk, married November 20, 1794. These alone do not make this folk art. The facts that the tree was begun too high up on the linen and presses against the border at the top of the design, that there is too much empty space at the bottom, which a

34

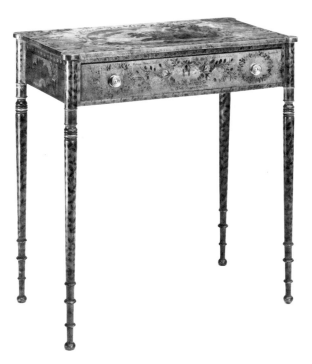

Fig. 21. *Chamber table decorated by Rachel H. Lombard. Bath, Maine, dated January, 1816. Maple, birch, pine, painted decoration; H. 84. cm. 57.895*

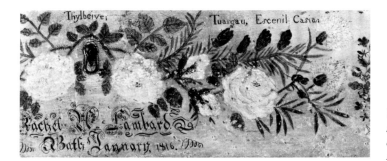

Fig. 22. *Detail of figure 21 showing decorated drawer and anagrams of Liveybeth, Augusta, Silence, and Isaac.*

Fig. 23. *Detail of figure 21 showing the chamber table top decorated with an epigram, a poem, flowers, and a large colorful castle which resembles one built near Limerick, Ireland.*

35

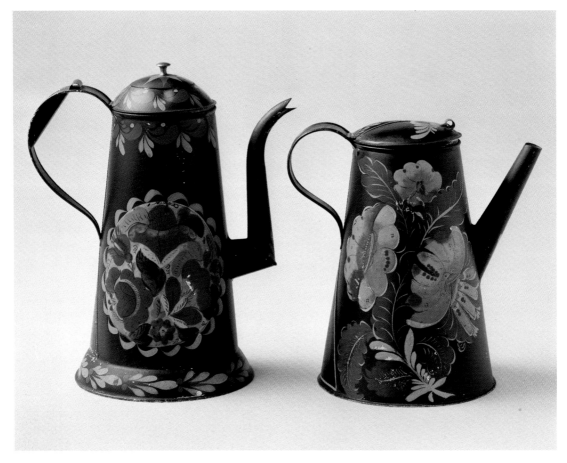

Plate II. *Painted tinned sheet iron teapots.* Left, *attributed to Frederick and Louis Zeitz,*
Philadelphia, dated 1875. H. 26.7 cm. 65.1599 Right, *probably Pennsylvania,*
1840-1860. H. 21.9 cm., with unusually exuberant decoration. 65.1673

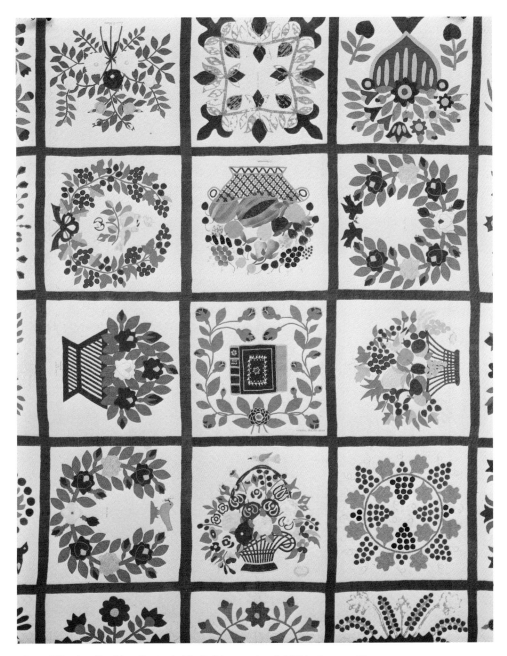

Plate III. *Appliquéd quilt, probably Baltimore, dated 1854. Cotton, silk,*
sepia ink details; L. 311.5 cm. 69.571

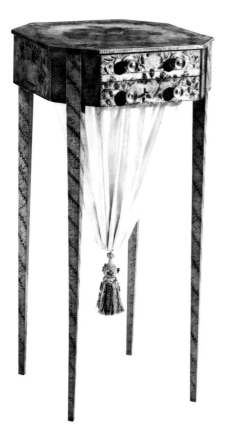

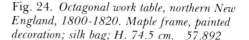

Fig. 24. *Octagonal work table, northern New England, 1800-1820. Maple frame, painted decoration; silk bag; H. 74.5 cm. 57.892*

revision of the design could have eliminated, and that the intertwined hearts at the bottom are shaky, unresolved forms, all satisfy the criterion of imperfectly produced goods.

Thorstein Veblen offered an explanation of the preference for handmade goods. In *The Theory of the Leisure Class* (1899), he argued, as have Glassie and Trent more recently, that pecuniary considerations are important in matters of taste; some people buy an object because of its great cost. This phenomenon, identified by Veblen as conspicuous consumption, is the common tendency to try to get the best social and psychological return for dollars spent. The purchases are bad bargains if considered only from a financial point of view, but in displaying one's ability to spend beyond mere necessity, they demonstrate financial power and social status. And the relationship between power and status is close; no matter how it is

38

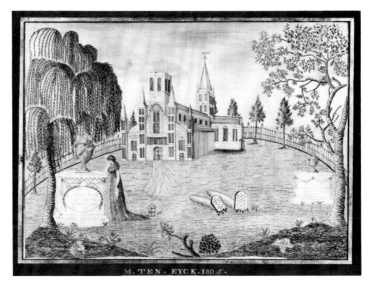

Fig. 25. *Needlework mourning picture, Margaret Bleecker Ten Eyck. Albany, New York, dated 1805. Silk fabric, silk yarns, animal hair; H. 56.5 cm. 58.2877*

Fig. 26. *Velvet painting, probably New York State, 1810-20. H. 46.4 cm. This scene appears in several velvet paintings and needlework pictures (see fig. 25) and is undoubtedly based on an English print. At the time, America had no Gothic churches resembling this. 76.218*

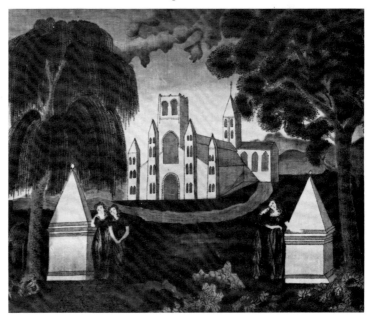

Fig. 27. *Jars, Solomon Bell. Strasburg, Virginia, 1870-80. Red earthenware, white slip, highlighted with yellow-green lead glaze and gray slip; pottery mark; H. 40.6 cm. Probably made by Richard Franklin Bell at his uncle's pottery. 67.1623.1,.2*

accumulated, Veblen maintained, great wealth eventually draws admiration and creates prestige.[28]

Robert Trent utilized the concept of conspicuous consumption when he explained that to be fashionable an object had to display an investment of blood and treasure—a great outlay for expensive materials or labor. Folk art objects seldom reveal the investment of much treasure, but there is abundant evidence of time-consuming hand labor. When some of these objects are figured at today's wage scales for handwork, it is clear that if made now they would be costly, some of them prohibitively so. In this respect, the folk art world is like other parts of the art world; money is a crucial consideration.

There is also irony in the emphasis on hand-production. Most of what passes for American folk art was produced either in the late eighteenth or nineteenth century in the northeastern part of the country. In other words, what seems folksy, traditional, and conservative, was produced in the most progressive, populous, industrialized, and changing part of the nation. Between 1790 and 1870 the American population went from about 4 million to 40 million, and by 1870, 60 percent of those people lived either in New England or the Middle Atlantic states. Nearly 20 percent more lived in the Great Lakes states. In 1790 only about 5 percent of the entire population lived in urban areas. In 1870 the national average was 25 percent in the cities, but in both New England and the Middle Atlantic states the figure was 44 percent. At the same date the core of the American economy could be incorporated in a rough triangle drawn between Bangor, Maine, Baltimore, Maryland, and Syracuse, New York.[29] What is known about American society in this region is not congruent with Redfield's concept of folk.

40

Fig. 28. *Embroidered and shirred rug, probably New England, 1800-1830. Wool surface, bast fiber backing; L. 140.3 cm. 64.1777*

The South, on the other hand, was closer to the Redfield notion of a folk society. In 1870 only 11 percent of the American population lived in the South, and urbanization was a modest 12 percent, up from 2 percent in 1790, and only roughly one-fourth as high as in the Northeast. Of the total labor force in 1870, only 7.5 percent of the Southerners were in manufacturing, as compared to 44 percent of the New Englanders.[30]

Presumably folk art should emanate from the rural, sometimes impoverished pockets of the South. But in fact most of it is from the populous industrialized North. Some of it was made by Northerners who had a predominantly conservative orientation, people who deliberately made or did things in an old-fashioned way. The objects these people made fit Glassie's definition of folk.

Many other objects were made by people who were affected by or actively participated in the dominant culture of nineteenth century America. They dabbled in sewing, painting, and carving, for example, as hobbies. These activities provided an emotional outlet or offered a contrast to their daily work. These avocations of the past parallel tie-dying, macramé, weaving, surfboard painting, and china painting of today.[31] Redfield's anthropological approach is largely irrelevant here.

Objects which are the product of the dominant culture of the eighteenth or nineteenth century should not be grouped in the arbitrary set called folk art but placed in the fuller context of the cultural matrix in which they originated. An album, or friendship, quilt is a fine example of nineteenth-century popu-

41

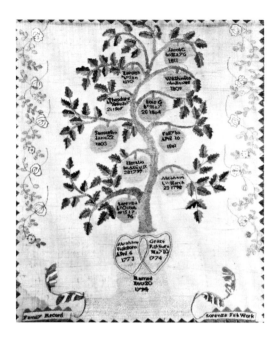

Fig. 29. Family Record, *Lorenza Fisk.*
Concord-Lexington area, Massachusetts,
probably 1811. Silk embroidery on linen;
H. 48.9 cm. 69.430, Gift of
Mrs. Alfred C. Harrison

lar culture. In the 1840s and 1850s they were what might aptly
be called a fad. They survive in quantity and are usually much
the same. The example in plate III is typical. These quilts
display similar designs, patterns and colors. Each was usually
made by a group of young women for a friend who had
become engaged to be married. Popular for only about a
generation, they were not traditional. Nor were their designs
traditional in the sense that they had been handed down from
mother to daughter; some squares were copied from patterns
illustrated in popular publications like *Peterson's Magazine*,
others may have been the product or design of professional
seamstresses.[32] The friendship quilts did not spring from an
idyllic rural setting but from cities like Baltimore, Bangor, and
Syracuse. They reflect the dominant culture of the Victorian
era. The same is true of stoneware jars, advertising signs,
ceramic figures, hooked rugs, and calligraphic work. In the
case of all of these objects, an understanding of their relation-
ship to the wider artifactual world of their time has been
deformed by the connotative meanings of folk.

Because folk art is defined intuitively and not empirically,
the category contains diverse artifacts produced through vary-

ing intentions. Some are the product of playful or experimental manipulation of a substance, others are deliberate. Some are tools for socialization or acculturation. Samplers, needlework pictures and painted decorations on furniture provided part of the training and educational process through which some children passed. Mourning pictures, lugubrious invitations to melancholy, were popular projects for young ladies early in the nineteenth century. They commemorated relatives or teachers who may or may not have been dead, and were a product of the dominant culture, not a conservative reaction to progress and innovation. But there was not much personal expression in these objects. Typically they were copies of prints or each other. And when inexpensive lithographed mourning pictures became widely available, they sold rapidly and replaced the earlier needleworked or painted examples.

Some of what the folk art writers say about handicraft is true, but sweeping generalizations based on a few examples are misleading. It is essential to know a good deal about the original context of each object to be able to determine what it reveals about the values associated with handwork.

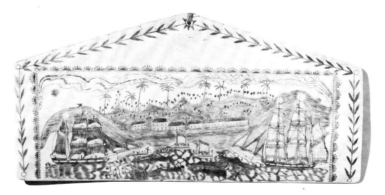

Fig. 30. *Scrimshaw plaque showing a south sea islands scene. America, 1825-65. Panbone; W. 36.2 cm. Panbone is rare because each sperm whale has only two pieces where the jaw hinges.* 67.890

43

Fig. 31. *Embroidered blanket, America, 1800-1830. Wool. handmade fringe; L. 302.9 cm. 69.558*

The fourth myth minimizes social and economic conflicts and might also be labeled the myth of a golden age, because the objects labeled folk art typically convey an image of a safe and serene life. There are few indications of violence, conflict, or struggle and little that is vicious, hideous, or obscene. The John Bell lion is a good example of much of this mood (Fig. 32). Instead of a dangerous and unapproachable carnivore, the potter modeled a diminutive, gentle, seemingly playful creature. In fashioning his version of the lion, Bell inverted reality, sweeping away the negative and fearsome aspects of the lion and remaking the beast to fit his own intentions.

Transformation is typical of folk art. Animals frequently undergo metamorphoses. On Fraktur made by German-Americans, broadly grinning lions cavort weightlessly in the company of birds and unicorns on the flat surface of the page (Fig. 33). The eagle, a fierce and intimidating bird of prey, retains only part of its predatory character. One naturalistic carved eagle perhaps originally crowned a standard carried in nineteenth-century processions (Fig. 34). In the abrupt and repetitive carvings of Schimmel, this naturalism is replaced by a formal, conceptual abstraction, making the bird more symbol and idea than physical being (Fig. 35). The owl, another predatory bird, is similarly dematerialized. In a small birch carving it is rendered as a rounded mass with the sculptural intricacy and appeal of a snowman (Fig. 36). Examples of this tendency abound.

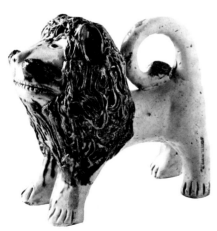

Fig. 32. *Lion, John Bell. Waynesboro, Pennsylvania, 1840-65. Buff earthenware, brown decoration, clear lead glaze; pottery mark; H. 18.7 cm. Made for a member of the Bell family. Of four known Bell lions, this alone bears the maker's mark.* 67.1630

44

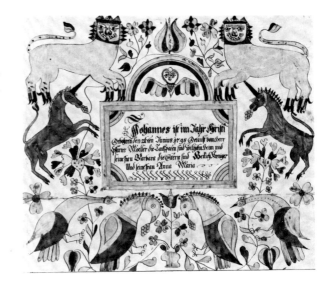

Fig. 33. Taufschein *(birth and baptismal certificate) of Johannes Kreniger, eastern Pennsylvania, ca. 1798. Watercolor and ink Fraktur; H. 32.7 cm.* 61.1109

The inclination to dematerialize and, in a sense, to screen visual reality, is not confined to images of animals. Human activities are subjected to the same process. A top-hatted hunter fires his flintlock musket at a deer across the surface of a horn priming flask (Fig. 37). The scene is dominated by a large and fantastic tree of no identifiable species bearing a rich crop of spiky flowers or fruit. The hunter and deer are as stylized as the tree, and, although the idea expressed is violent, the image is no more disturbing than a Thurber cartoon. Similarly, a painting of George Washington by Frederick Kemmelmeyer shows the general seated on a high-spirited horse (Fig. 38). To the left, rows of diminutive, smiling soldiers stand at attention, while, in the upper right, a woodpecker hammers away at a dead tree, possibly a humorous allusion to the rat-a-tat-tat of the snare drums below. Washington is reviewing troops called to subdue the rioting farmers in western Pennsylvania, but the

Fig. 34. *Eagle, America, 1775-1875. Painted white pine; H. 43 cm. Possibly used as a flagpole decoration.* 59.2371

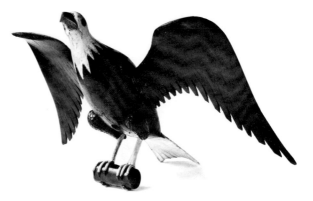

45

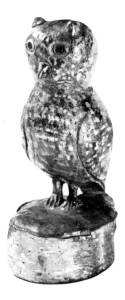

Fig. 36. *Owl, America, 1850-1900. Varnished birch; H. 26.6 cm. 59.1501*

scene depicted is not violent. The glorification of military life or at least the suppression of some of its less appealing aspects is not confined to folk art. Kemmelmeyer's work, however, deals less with physical substance and more with sign and symbol than contemporary paintings by academic painters. If it is not farther from myth and legend, it is more distant from sound and smell, weight and volume. Along similar lines, little is menacing in a wooden weathervane carved in the shape of a kneeling Indian with a drawn bow (Fig. 39). The Indian is flattened, simplified, and caricatured. The product is a gaunt parody more amusing than intimidating.

John Bell's lion is not an isolated instance of the transformation, but only more extreme and, consequently, more obvious. It elicits strong and positive responses. To many viewers it is a charming, appealing, even endearing object. It is not, however, realistic. A smiling lion less than eight inches tall (Fig. 40) is fantasy, a term rarely mentioned in the rhetoric of folk art. Writers instead emphasize the reality of folk art and contrast it with the art of the elite. The latter, so the argument goes, wears a straitjacket of gentility which inhibits its creative powers while folk art, with "no frills, no postures, no dictates from an established or cultivated elite," is "a no-nonsense art by the people produced in an ambience of private conscience and outspoken mind."[33]

The argument that folk artists painted exactly "what people and things really looked like," cannot be taken literally. Folk

Fig. 35. *Eagle, attributed to Wilhelm Schimmel or Aaron Mountz. Cumberland County, Pennsylvania, 1865-1890. Painted linden; H. 75 cm. This is the largest known eagle attributed to either of these artists. 59.2350*

46

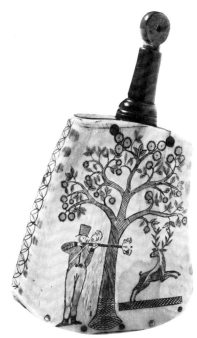

Fig. 37. *Priming flask, America, 1825-1900.*
flattend Holstein horn, engraved;
H. 14.9 cm. 67.863

art, like high art, is visual reality monitored. In one drawing, a line of soldiers with faces almost as unearthly as those Picasso later invented, stands before an officer a full head taller. (Fig. 41). This is an image not of physical reality but of social reality, reminiscent of medieval illuminations where Christ dwarfs his disciples and an emperor his subjects. The drawing obeys an ancient rule of visual representation largely outmoded by the

Fig.38. GENERAL GEORGE WASHINGTON, Reviewing the Western Army at Fort Cumberland the 18th of October 1794, *Frederick Kemmelmeyer. Maryland, post 1794. Oil on linen-backed paper; H. 46 cm. 58.2780*

47

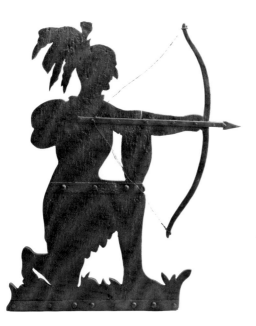

Fig. 39. *Weathervane, America, 1800-1840. Painted white pine; H. 116.2 cm. 51.65.1*

naturalism of the Renaissance: He who is most important is largest. This may be an example of the folk artist "expressing what he sensed and felt," but reality is no more valid or invalid than that recorded by academic artists painting wealthy patrons.[34]

Alternative definitions of reality exist. The Bell lion is appealing because it does not mirror visual reality. Its reality is its affect on the emotions. In trying to explain the fascination of this little lion it may be possible to generalize about the many animal images that appear in folk art. They are abundant; nearly half of the objects in folk art exhibitions explicitly refer to animals. The history of animal imagery is as old as man's design history. Animals have provided food, drink, clothing, transportation, and energy. Man has made them gods, totems, guardians, mascots, decoys, toys, and companions (Figs. 43-50). The variety of roles assigned to animals has made it difficult to know what responses and association animals provoked in the past when they appeared on or as man-made objects. However, it is possible to speculate about their meaning for the people who write about folk art today.

One of the most fascinating facets of depicted animals is as receptacles for projected elements of man's own character. A familiar instance in which animals serve as extensions of man is

Fig. 40. *Full face view of the Bell lion.*

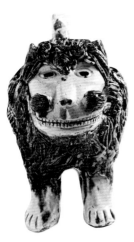

48

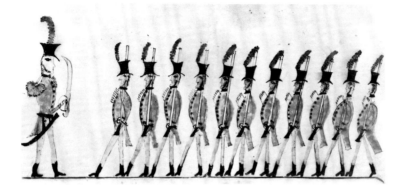

Fig. 41. *Drawing, possibly Pennsylvania, 1810-20. Watercolor and ink Fraktur; L. 22.5 cm. 61.1114*

in the popular animal stories which have been so large a part of literature from Aesop's time onward. In this world of purposeful fantasy, animals provide a degree of abstraction or psychic distance which makes moral or intellectual concepts more clear-cut and comprehensible. Thus while the Bell lion tells no identifiable story, he is reminiscent of the others who frolicked

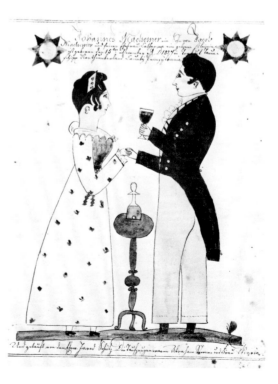

Fig. 42. Taufschein *(birth and baptismal certificate) of Johannes Machemer, attributed to the Reverend Henry Young Turbot Township, Northumberland County, Pennsylvania 1827-1840. Watercolor and ink Fraktur; H. 31.1 cm. 58.120.20*

49

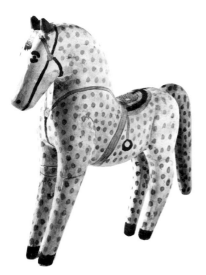

Fig. 43. *Toy horse, Carlisle, Pennsylvania, ca. 1840. Carved, painted tulip; H. 32.5 cm. 60.709*

through childhood tales. He generates a positive emotional response charged with nostalgia.

The existence of childhood stories is not the only reason miniaturized animals appeal to people. The man-made Bell lion and the man-made tales are not dependent on each other but spring from the same impulse: animals are emotional focal points. They provide an outlet for tender feelings that the tensions and complexities of human life repress or thwart. Their small size is crucial. Many animals as they exist in nature are dangerous beasts: heavier, faster, or more powerful than

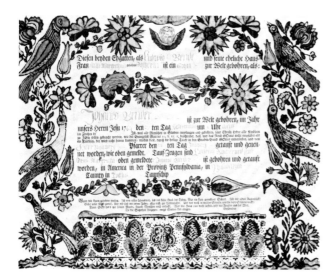

Fig. 44. *Printed Taufschein (birth and baptismal certificate) of Johannes Bender, attributed to Heinrich Otto, near Ephrata, Pennsylvania, dated 1784. Press printed in three colors of ink; block printing and freehand decoration added later. H. 34 cm. 58.120.17*

50

Fig. 45. *Whistle, probably Pennsylvania, dated 1821. Red earthenware, incised decoration, clear lead glaze; H. 8 cm. 60.639*

humans. They engender fear. The sketched and modeled animals create no fear. Their small size evokes protective instincts. There is a relationship between love and smallness. More than two centuries ago Edmund Burke perceived this link and noted that in most languages objects of love are spoken of "under diminutive epithets." He summed it up succinctly: "We submit to what we admire but love what submits to us."[35]

The Bell lion at Winterthur is one of three which survive. All are believed to have been made for members of the Bell family. If this is true, each might have represented a gift of love, like A. A. Milne's gift of Winnie the Pooh to his child. The little earthenware lion therefore sheds light on an important side of human nature and an alternative definition of reality.

Burke's analysis helps to explain the attraction of the Bell lion or of a bookmark filled with rows of pert, colorful birds (Fig. 51). It gives more meaning to innumerable small clay, glass, or wooden animals. There is reality in these objects but it is not the reality perceived by many folk art rhetoricians. The reality is that many people have had and continue to have

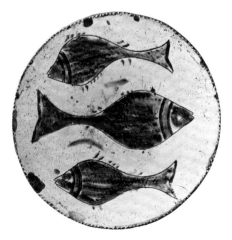

Fig. 46. *Plate, Pennsylvania, 1800-1825. Red earthenware, white slip, incised and combed decoration, green coloring, clear lead glaze; Diam. 30.9 cm. Combed decoration is not usually seen in American slipware. 55.109.5*

51

Fig. 47. *Figure of a lion, probably Pennsylvania, 1840-80. Red earthenware, brown glaze; H. 16.2 cm. 59.2268*

difficulty coping with life and finding personal fulfillment. They have emotional needs which are not met and they use objects like small clay animals as vehicles of fantasy and escape to a world they can control and where they matter. The folk art writers would have us believe that the peace and calm that can be found in these objects is an accurate reflection of what life was like in the past. On the contrary, the past was as complicated, confusing, and unsettled as today. These objects provided light in darkness, serenity in chaos, and that may be why we still make and appreciate such objects.[36]

The folk writers may have taken works like Edward Hicks's *The Peaceable Kingdom* at face value in spinning their myth of a conflict-free past. The blissful, idyllic world of Biblical promise in which the lion lies down with the lamb and the meek and

Fig. 48. *Vase on pedestal base, Anthony W. Baecher. Winchester. Virginia, 1868-89. Red earthenware, white slip, relief decoration, green glaze; pottery mark; H. 24.6 cm. 67.1679*

mild dwell in harmony with the strong and agressive is expanded and projected upon the past. The Hicks painting is a vision, a dream, a hope, and, perhaps, an hallucination. It does not reflect a harmonious and free society, although it might express the wish for one. The apparently direct unequivocal faith and unambiguous meaning of Hicks's painting have been generalized to explain the society around it. The folk artist does not produce a more accurate rendition of reality than the elite artist; he just reflects a different reality. Condemning one or the other makes less sense than separately evaluating the two for what they reveal about the way man comes to terms with the fundamental fact of existence.

There are social reasons for the perpetuation of the myth of a conflict-free past. Charles Keil quotes a white master of ceremonies who explained to his audience "these boys just love to play the music; that's all they do, day and night."[37] The implication is that these musicians are harmless and will not cause trouble; they will just play their old time songs. This is what some people want the folk to have been like too, so they define as folk art objects which seem harmless and free of conflict. In the construct called folk art they can find an earlier, simpler but mythological age devoid of class struggles and competition when social classes and races knew their places and were happy in them.

Part of the myth of the conflict-free past may be generated by the use of the word art. *Let Us Now Praise Famous Men*, a moving book about the lives of the poor, contains a brilliant and poignant passage in which the author, James Agee, cries out "above all else; in God's name don't think of it [any piece of work] as art. Every fury on earth has been absorbed in time, as art, or as religion, or as authority in one form or another. The deadliest blow the enemy of the human soul can strike is to do

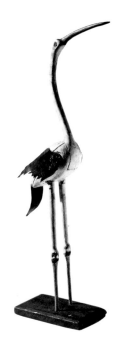

Fig. 49. *Crane, America, 1850-75. Painted whitepine, tinned sheet iron; H. 69.2 cm. 69.1890*

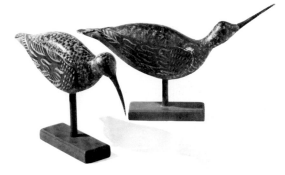

Fig. 50. *Carved snipe, eastern United States, 1850-1900. Painted wood; L. (left) 30.5 cm, (right) 35.9 cm. 65.1988,.1989*

53

Fig. 51. *Bookmark, eastern Pennsylvania,*
1790-1820. Watercolor and ink Fraktur;
H. 17 cm. 57.1

fury honor."[38] Labeling something art makes it safe, genteel,
proper, inoffensive; it becomes domesticated and docile. Life
is not like that; neither are objects.

Not all folk art is really domesticated and docile. Some may
have more of mischief or menace than immediately appears.
This is obscured by the rhetoric about folk art which stresses its
directness of statement and uncomplicated forthrightness. If
folk art objects are examined with the same care and determi-
nation with which we approach high-style objects, complexity
and conflict emerge.

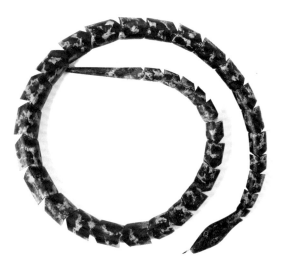

Fig. 52. *Jointed snake, America, 1850-1900.*
Linden, cord; L. 74 cm. 61.1147

54

Fig. 53. *Monkey fiddler and monkey drinker, attributed to the Milton Hoopes, Pottery. Downingtown, Pennsylvania, 1842-64. Red earthenware, patches of brown glaze, clear lead glaze; H. (left) 21.4 cm. A related monkey figure was given to the Chester County (Pennsylvania) Historical Society by a descendent of Milton Hoopes.* 59.2269, 59.2279

Consider what appears to be a toy—a jointed wooden snake of uncertain date (Fig. 52). Similar objects were made throughout the nineteenth and twentieth centuries. A snake, however, is never just a toy; the form and idea of a snake probe deep undercurrents of emotions and associations.

The equivocal attitudes toward the snake are apparent in the many often conflicting roles it has played in our myths and imagery. Recent surveys of the use of the snake emblem on American artifacts reveal that it has been used to symbolize temptation, evil, wisdom, eternity, disunity, and the United

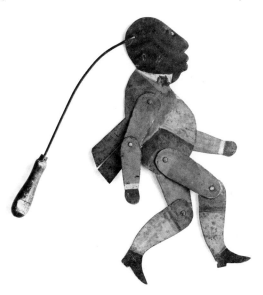

Fig. 54. *Jointed figure, America, 1860-1930. Painted sheet iron, iron wire, brass; L. 45.7 cm.* 64.870

55

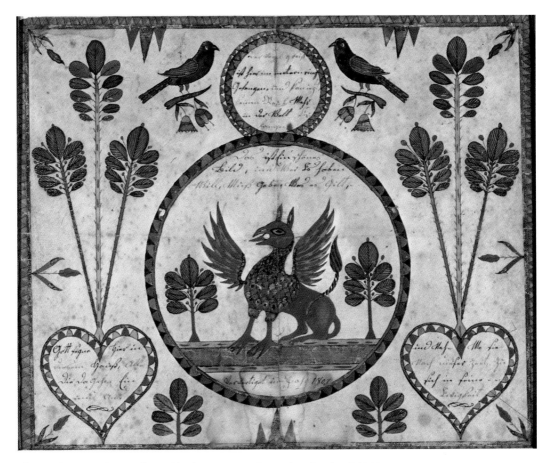

Plate IV. Haus-Segen *(house blessing), eastern Pennsylvania, dated 1803.*
Watercolor and ink Fraktur; H. 31.7 cm., by sight. This is probably
the most unusual and rare Fraktur in the Winterthur Collection. 57.1190

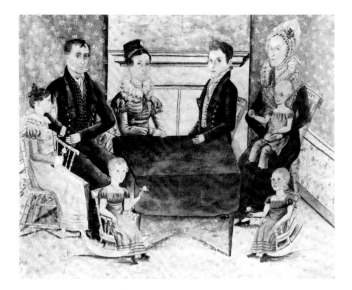

Fig. 55. *Family portrait, attributed to the Schaeffers-town Artist. Probably Lebanon County, Pennsyl-vania, 1830-1840. Water-on paper; H. 44.6 cm. 57.1123*

States itself. The American use of the animal is an extension of age-old patterns including the Judeo-Christian tradition, Greco-Roman iconography, and the cults of Indians of the Plains, the Southwest, and Mexico. E. McClung Fleming out-lined the remarkable characteristics which may account for man's fascination with this creature. "It lives below the ground, can swim in the water, move rapidly on the earth, and climb trees; its wavy pattern of locomotion seems the essence of abstract energy; its bite and embrace can be deadly; its silence of motion and expression suggests a canny independence; its practice of shedding an old skin for a new one suggests rebirth and immortality."[39]

The associations of the snake with evil and temptation have been most persistent. If the associations are only subliminally present in the jointed wooden snake, they are more explicit in a strange and apparently unique lead-glazed red earthenware snake on an earthenware slab (Pl. V). Which of the meanings in Fleming's list it refers to is unclear. The hole in the base near the snake's head suggests that perhaps it was intended as a plaque to be hung on the wall; the snake's twisted form is also vaguely reminiscent of the physician's staff of Asclepius. But if the slab were hung, the snake would appear to fall outward and backward. Should not a deadly rattlesnake be confined or contained? It slithers on a slab outlined by a quick, wiggly line

57

Fig. 56. *Hanging cupboard, possibly mid-Atlantic region, 1775-1825. Wood, painted in casein colors; H. 108 cm. 67.844*

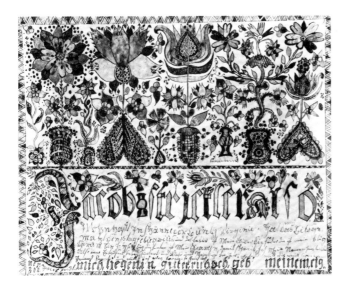

Fig. 57. Zierschrift *(decorative writing), signed Jacob Strickler. Massanutten settlement (near Luray), Shenandoah (now Page) County, Virginia, dated February 16, 1794. Watercolor and ink Fraktur; H. 31 cm. 57.1208*

augmented by Xs at each corner. Are these marks meant to ward off or contain evil? What does this object, allegedly so forthright, mean? Why a rattlesnake on a slab? Is this a temperance image from the nineteenth century, symbolizing the evil and temptation of drink, like the bizarre snake jugs made by the potters of Anna, Illinois? The questions remain unanswered. Whatever its specific meaning, the snake plaque provides additional evidence that the world of folk art is not blissful and innocent but as full of troubles and temptations as the present.

There are other indications of stress and conflict in folk objects. The inscriptions on Germanic sgraffito plates are often

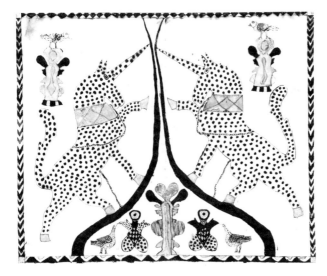

Fig. 58. *Drawing, eastern Pennsylvania, 1795-1830. Watercolor and ink Fraktur; H. 31.8 cm., by sight. 61.1113*

58

Fig. 59. *Boy with a rooster, attributed to Jacob Maentel, York, Lebanon, or Lancaster County, Pennsylvania, 1815-25. Watercolor; H. 20 cm. 57.1119*

droll and humorous but they often allude to another side of life. Some contain a reference to man's mortality: "This dish is made of earth and clay / And thou, oh man, art of the same." Others pertain to obstinacy: "He who allows himself to be corrected / will soon become wise / But he who refuses to be corrected / will remain a fool" or "D stands for dumkopf who can't stand learning"; infidelity: "Love only me or let me be / Keeping things hidden brings trouble"; and explicit sexuality, like violence, is usually purged from folk art: "Were there no men or roosters / Left empty would be cradles and chicken pens." A few humorous inscriptions also reveal a malevolent tone indicating hostility, or frustration: "I do not like it at this table / The cook does not wash her fingers"; "I only cook what I can cook still / what the pig won't eat my husband will"; and "I am very much afraid my plain daughter will find no mate."[40]

Humor often disguises strong feelings. With so many of the objects labeled folk art, their humor has been taken at face value. Indeed only more research can determine whether things really mean what they seem to mean. The two monkey figures in clay, probably made in Pennsylvania around the middle of the last century, are examples of this problem (Fig.

59

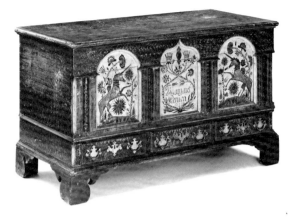

Fig. 60. *Blanket chest, Lehigh County, Pennsylvania, dated 1788. Tulip poplar, painted decoration; H. 72.1 cm. 59.2804*

53). Like snakes, monkeys have an extended history of meaning, most of it negative. In antiquity the monkey usually represented the weaker side of man, dominated by animal instincts. In medieval imagery, the monkey was considered a demon and sometimes actually identified with Lucifer, the fallen angel. Darwin's revolutionary ideas in *The Origin of Species* only reinforced the attitude that the monkey was an imperfect step toward humanity, humanoid in appearance but bestial in behavior.[41]

Monkeys often appear in contexts of gluttony and sensuality. Their use in rococo design, the product of a period sometimes called the Age of Pleasure, in the company of satyrs and other unrepressed creatures is further evidence of their association with the baser aspects of man. The most obvious antecedents for these redware figures, the famous Meissen monkey band and its numerous replicas, probably contain some derogatory meaning, but the later American examples are more explicitly bad mannered. One monkey plays a violin

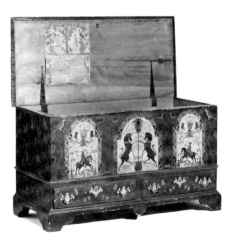

Fig. 61. *Blanket chest with drawers, upper Berks County, Pennsylvania, 1765-1810. White pine, painted decoration; H. 70.5 cm. Press printed religious broadside pasted to lid. Drawing on broadside attributed to Georg Frederich Speyer, probably Berks or Dauphin (now Lebanon) County, Pennsylvania, 1785-1800. Watercolor and ink; H. 40.7 cm. 55.95.1,2*

60

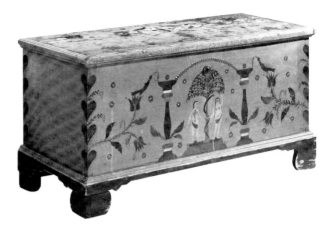

Fig. 62. *Blanket chest, Lebanon County, Pennsylvania, 1765-1800. Painted pine; H. 62.8 cm. 57.99.4*

while puffing on a cigar; the other drinks out of a bottle, a reminder of the temperance struggle of the last century. The message seems to be a warning against alcohol and sensual pursuits, which will make a monkey out of man. It is also possible that these images were racist, for what J. Stanley Lemons calls scientific racism distorted Darwin's teachings to argue that blacks were less than human and they were sometimes shown with monkeylike features.[42]

If racism is connoted in the monkey figures, it is explicit in the jointed dancing figure which may have been intended as a toy (Fig. 54). But toys do more than amuse; they also instruct. Children who played with this figure and even those who made

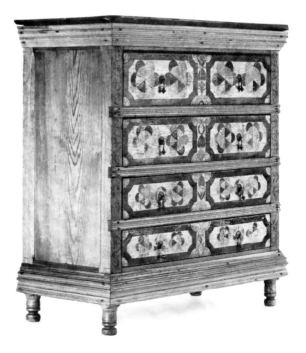

Fig. 63. *Chest of drawers, probably the Hadley area, Massachusetts, 1695-1720. Red oak frame, painted decoration; H. 114.9 cm. 57.54*

61

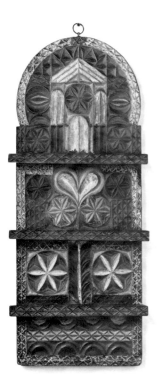

Fig. 64. *Spoon rack, possibly mid-Atlantic region, 1750-1800. Tulip, chip carved, painted; H. 53 cm. "Friesian" chip carving, such as this, is frequently found on imported articles. 59.2813*

such objects may not have fully understood the racism expressed in this stereotyped black man. But the laughter this evoked revealed a pervasive lack of sensitivity. This figure shares some of the characteristics of Zip Coon, who was a city dandy. His fancy clothes but coarse features were intended as comic contrast. The full lips, broad nose, and sloping forehead, to indicate minimal intelligence, were all part of the black stereotype. By the end of the last century, blacks had become the principal comic character of America, a reflection of the dismal race relations of that period. It was in 1896 that the song "All Coons Look Alike to Me" was written. The title pretty well sums up the sentiments expressed in this metal figure.[43]

A conflict-free past is a myth spun of fantasy and the misreading of the artifactual and written record, but it is part of the romanticism of folk art. Its divergence from reality often goes unnoticed.

NATIONAL UNIQUENESS

When American folk art was "discovered" in the early years of the twentieth century, it was associated with the modern art movement. Many of the objects in what was probably the first public exhibition of American folk art, held in New York in 1924, were drawn from the collections of major contemporary artists like Charles Sheeler, Charles Demuth, and Yasuo Kuniyoshi. Artists like Elie Nadelman, Robert Laurent, and William Zorach were also associated with folk art's early popularity. Advocates of modernism stressed the honesty and sincerity of folk art. They sanctified any work that seemed to hark back to periods when vision was fresh or to stages in life when

Fig. 65. *Dome-top box, Lancaster County, Pennsylvania, dated February 12, 1814. Poplar, painted decoration, punched tin escutcheon; H. 20 cm. 65.1891*

62

Fig. 66. *Wall sconces, tinned sheet iron:* left *probably New England, 1830-60, H. 34 cm. 60.708;* center *America, 1825-75, H. 51.1 cm. 67.1549.2;* right *America, ca. 1871, H. 32.1 cm. 59.2101*

conventions had not yet corroded personal spontaneity. They saw modernism as the logical extension of intuitive American folk art.

Concurrently other people regarded the apparent linkage between folk art and modern art as less important than the fact that folk art demonstrated a "two-hundred-year-old unbroken tradition of all that was characteristically American."[44] This group implied that while modern art was a European movement, Americans of an earlier time had anticipated many of the aesthetic concepts on which it was based; the American folk artists recognized the subtleties and pleasures of abstract art long before Europeans "invented" it.

Because of the two orientations, the word *American* is used in conjunction with the term *folk art* in different ways. Much of the time it is used descriptively, as a way of indicating scope or limitations, but it is also used as a value-adding modifier raising the objects so identified to a higher level. It confers prestige because the American way of life is presumed superior and identifying a folk object as American makes it more valuable and more costly.

The rhetoric of American folk art confounds notions of freedom, democracy and personal expression. Joseph Bishop maintains that American folk art is uniquely American, repre-

63

sents the American people, and is the true expression of the free man. As he puts it, "Because I am dedicated to the preservation of individual freedom and the related ideas which nourished folk artists, I will always prefer their efforts to the European-inspired academicians." John Gordon represents the most extreme position: "the American craftsman worked as a free man" unrestricted by the bonds of guilds or the demands of an aristocracy. He labored in an "environment of no restraints" with "the widest latitude of personal approach and innovation. The result was democracy at work; . . . in America each craftsman produced the fresh statement. Here, in the only democracy at work, a classless and free society granting gifts of opportunity, the miracles did happen. The flowering of free spirits produced a meaningful and abundant outpouring of expression that clearly revealed American life. The atmosphere nurtured the spirit. . . . And is this wondrous output not the great democracy's distinct contribution to world art."[45]

Gordon's "wondrous output" buttresses the mythology of folk art and is too fatuous to merit an extended rebuttal. Perceptive writers have long seen the distortion in calling folk art the real American art and the true expression of the American people. James Thomas Flexner, John Kouwenhoven, E. P. Richardson, and others have pointed out that much of what is called American folk art represents a transference to these shores of long established European traditions. In *Pattern in the Material Folk Culture of the Eastern United States,* Glassie devotes considerable space to tracing the pre-American antecedents for many artifacts which became commonplace in American folk culture. But just as the myth of the melting pot supported the belief that when immigrants came to this country they threw off associations with their native lands and retooled as that new product known as the American, the myth of nationalism maintains that American material culture at an early date became distinct from and superior to that produced in the rest of the world.[46]

It is easy to fall into the traps of chauvinism or nationalism. The myth of American uniqueness in folk art is admittedly less dangerous than other nationalistic myths which can be trans-

lated into direct political action. Nonetheless, it inhibits empirical study of the objects. It leads writers to attempt to discover the American component of American art without first asking whether anything is American or, even more basically, the merit of this line of inquiry. Although it is interesting to look for distinctive American solutions to problems, it is also absorbing to observe the perpetuation of old solutions over centuries and across seas.

Having discussed the myths surrounding folk art, the operative questions can be posed once again. Does it really matter whether or not these myths are false? Since these objects were made long ago, does it make any difference what is said about them? The answer to each is an emphatic yes! William Faulkner once noted "The past is never dead; it isn't even past." Our understanding of the past affects our actions in the present:

> If you do not know your own history, you'll be ignorant and helpless before someone who does claim to know it. He can tell you what happened to cause you and your society to be the way they are, and he can therefore tell you what needs to be done now to bring about change. He may be wrong or biased but if you do not know the true story, you will never find this out and you might believe him. Thus, he will be able to control you.[47]

The objects called folk art are important not because they epitomize the virtuous lost past of America but because they provide a better balanced picture of how people lived and what sort of things they surrounded themselves with. They reveal the multifaceted nature of American culture and help us understand today's society and the objects that surround us. Knowledge is self-defense.

THE INFLUENCES ON FOLK ART

TRADITION

Tradition is a key ingredient in the concept of folk. The objects identified as American folk art, however, are the products of diverse cultural milieux, and consequently the type and degree of tradition they display show considerable variation. Tradition is a relative and imprecise term, but archaeologists have given it sharper meaning. In describing distribution of artifacts over space and their duration over time, they posit *tradition* at one extreme and *horizon* at the other.[48] Tradition refers to phenomena of relatively long temporal duration and narrow geographic range; horizon means limited temporal duration with broad geographic range. Plotted on a graph in which the vertical axis signifies time and the horizontal axis space, tradition is a long, narrow, vertical band never very wide while horizon is a very short band of great breadth. Ideally, traditional objects lack horizon and are undatable. In some of the materials studied by folklorists this is the case. However, because the category of folk art has been constructed with more regard for the standards of dealers and collectors than for those of folklorists, most pieces identified as folk art contain distinct elements of both tradition and horizon. Generally tradition is manifested in the form or shape of an object and horizon in its decoration, but this is by no means always the case.

The objects grouped together as American folk art are normally the products of one of three different cultural conditions. Some are from a distinctive ethnic sub-culture—Frakturs and painted furniture of the Pennsylvania Germans, Santos made in the Spanish southwest, and baskets, blankets, and ceramics produced by Indians. Others are selected examples of American popular or dominant culture which fit certain requirements of tradition, decoration, and competence—quilts, painted furniture, ceramics, weathervanes, and advertising signs. The third group embraces the products of cultural

66

Fig. 67. *Miniature chest, Pennsylvania, dated 1785. Pine, casein colors for decoration and inscription; H. 22.5 cm. 59.2806*

collision, a highly disparate mixture of objects representing the interaction or amalgamation of two or more cultural strands—a clock of Anglo-American form but decorated with Pennsylvania-German imagery (Pl. VIII) fits in this category.

Objects made by or for Germans settled in Pennsylvania and neighboring states constitute a major category of American folk art. Here more than in any other immigrant group in the northeast was an easily recognizable material culture tradition in close proximity to but distinct from Anglo-American culture. Yet the culture, even among the more conservative pietistic sects, was not static and many of their objects bear extensive evidence of horizon as well as tradition.

Chests are a good example of these phenomena. Germans in America, like their countrymen on the Continent, retained the chest as an important article of household furniture long after the form had passed out of use in the Anglo-American community. Typical examples, directly traceable to European antecedents, are made of softwood, "sit on stubby turned legs, are fitted inside with a 'till' for sundries, painted a solid color or 'grained' in half-hearted imitation of some wood finer than pine or poplar," and are virtually undatable.[49] Perhaps because they are ubiquitous and inexpensive they are not usually included in folk art exhibitions. Those described as folk art are more elaborate.

Fig. 68. *Miniature chest, Lancaster County, Pennsylvania, dated 1773. Walnut,* Wachseinlegen *("Wax inlay") technique; H. 19 cm. 65.2256*

67

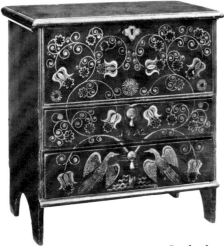

Fig. 69. *Chest with drawers, Taunton area, Massachusetts, dated 1742. White pine, painted decoration; H. 70.8 cm. 54.510*

Such chests display traditional and innovative elements side by side. In one example dated 1788 (Fig. 60) the form is traditional but the construction is not. Earlier chests were made of joined construction, a technique which created a frame held together with mortise and tenon joints into which panels were slid. This chest is made of broad boards held together with dovetails, a technique used on the most up-to-date furniture produced in America at the time. The applied facade of the chest, with its three architectural niches supported by columnar elements perpetuates the appearance of the earlier joined chests and continued a tradition which can be traced back to the sixteenth century. The birds, beasts, and flowers under ceremonial arches are typical Pennsylvania-German imagery, but the bracket feet on which this chest rests resemble those used on contemporary Anglo-American case furniture.

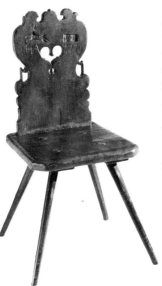

Fig. 71. *Brettstuhl ("plank chair"), possibly Pennsylvania, dated 1770. Painted walnut; H. 84 cm. 63.827*

Change over time in Germanic tradition is demonstrated by a chest decorated with painted figures of Adam and Eve on the front (Fig. 62). In some ways this chest has more traditional elements than the last, for it is a plain six-board chest without drawers (drawers in the lower section were a more recent innovation). Moreover, the method of construction in the Adam and Eve chest was similar to that used on the earlier Germanic chests known in America. The dovetailed joints are butted, rather than mitred as they are in later chests. The portrayal of Adam and Eve was conventional in Germanic imagery. The tree with the snake curling upward around it and the figures on either side, almost indistinguishable by sex,

68

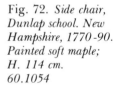

Fig. 70. *Miniature chest, possibly America, 1800-1850. Painted tulip; H. 19 cm. The chest is nailed and glued, and the corners are mitred: it may have been constructed from scraps of picture frame molding.* 67.710

repeat a composition found in the eighteenth and nineteenth centuries on samplers and needlework, ceramics, metalwork, graphics, and many other media traceable to the Middle Ages.[50] All are part of the same iconographical set as the figures of Adam and Eve on a Fraktur still remaining inside another, probably earlier, chest (Fig. 61). Alterations to traditional surface treatment are easily visible in the Adam and Eve chest. Instead of traditional applied architectural motifs and a dense, crowded design, the flat surface is painted in an open, airy, planar manner closer in concept to late eighteenth- and early nineteenth-century American wall painting.

A different aspect of tradition appears in an object from the dominant Anglo-American culture, a New England chest of drawers (Fig. 63). The joined construction and the relationship to documented pieces indicate it was made in the late seventeenth or early eighteenth century. Joinery was typical of most furniture of that period; however, the form, a chest of drawers, was still relatively new. It gradually replaced the chest as one of the major storage places for textiles and clothing. Although the Pennsylvania-German chests represented an older storage tradition, this progressive form may predate the construction of the many Pennsylvania-made chests by seventy-five to one hundred years. But this chest of drawers is traditional in its painted surface. Each drawer is divided into two symmetrical panels within which a compass was used to form designs. The designs, produced with ease because of the availability and limitations of compasslike tools, are not innovative. Similar patterns have been independently invented and reinvented throughout history in areas widely separated by time and space.

Fig. 72. *Side chair, Dunlap school. New Hampshire, 1770-90. Painted soft maple; H. 114 cm.* 60.1054

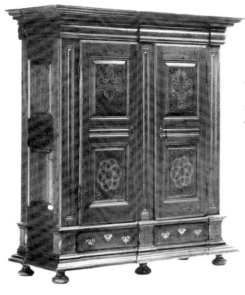

Fig. 73. *Schrank, Lancaster County, Pennsylvania, dated February 17, 1768. Walnut* Wachseinlegen *("Wax inlay") technique; H. 227.3 cm.* 65.2262

Fig. 77. *Desk, owned by Jacob Masser, Mahantango Valley, Pennsylvania, dated 1834. Black walnut, painted decoration; H. 124.8 cm. Ornamental motifs derived from printed* Taufschein. 64.1518

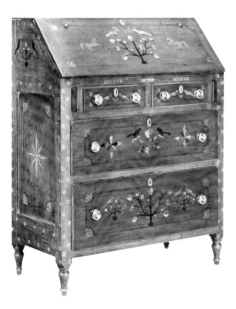

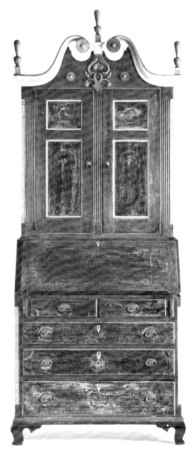

Fig. 75. *Desk and bookcase, Pennsylvania, 1780-1810. Painted white pine; H. 254.3 cm.* 57.502

The pattern on the chest of drawers is common on objects identified as folk art. But it reappears from time to time in high art too, in the work of Russian supremacists, art deco designers, and contemporary painter and sculptor Frank Stella.

Social scientists have as yet been unable to adequately explain man's tendency to cling tenaciously to old forms, sometimes keeping them the same for generations, and only grudgingly allowing a new idea or technique to gain a foothold. The tendency is clear in the history of furniture. People with different backgrounds and values reconciled the varying ideas of the chest and the chest of drawers in different ways. The chest is an ancient form of furniture, possibly a furniture archetype; it is one of a few basic furniture ideas which have survived relatively unaltered from antiquity to the present. Cedar-lined chests available today are replications of forms known to the ancient Egyptians, Greeks, and Romans as well as to most people since then. The chest was particularly prominent in the Middle Ages, when it was the most abundant piece of case furniture. Historians have argued that the prominence of the chest was related to the unsettled nature of medieval life and that it was an attribute of a largely migratory or nomadic society. After the rise of modern cities and a less mobile way of life it began to be replaced by other more specialized, larger and less portable forms. The chest is a portable piece of furniture. The few exceptionally large examples that survive

Fig. 74. *Jug, possibly Connecticut or mid-Atlantic region, 1800-40. 61.162*

Fig. 76. *Windsor side chair, New England, 1795-1815. Painted aspen, soft maple, white oak; H. 87.6 cm. The unusual ears and bow are one piece. 64.1173*

71

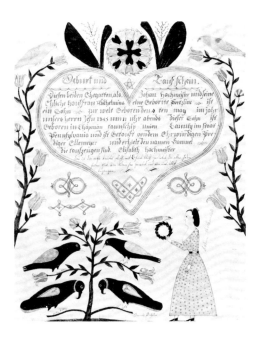

Fig. 78. Taufschein *(birth and baptis-mal certificate) of Samuel Hachmeister, signed Francis Portzline. Chapmann Township, Union County, Pennsylvania, 1845-55. Watercolor and ink Fraktur; H. 38.8 cm. 65.602*

Fig. 79. *Candlestand, probably northern New England, 1810-1830. Painted birch; H. 65 cm. 57.1101*

Fig. 80. *Covered cup, possibly Pennsylvania, 1820-50. Maple, painted decoration; H. 18.1 cm. Made in the style of Joseph Lehn but lacking the distinctive coloration of his wares. Possibly an apprentice piece. 67.1830*

Fig. 81. A Plan of New Gloucester. State of Maine, *Joshua H. Bussell. Alfred, Maine, dated January 1, 1850. Watercolor, ink, chalk; H. 52 cm. SA 1535*

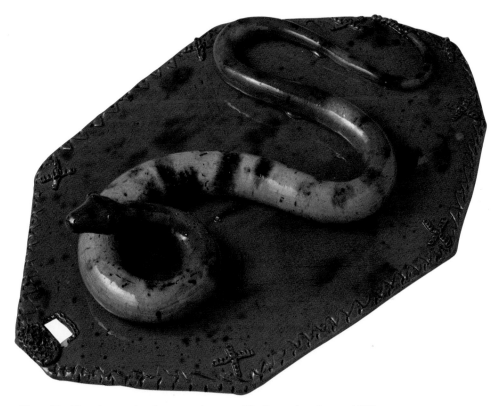

Plate V. *Hanging snake plaque or sign, possibly Pennsylvania, ca. 1850.*
Red earthenware, incised and relief detail, splashes of green and brown,
clear lead glaze; L. 41.2 cm. 59.2294

Fig. 82. *Overmantel hunting scene, probably Massachusetts, ca. 1800. Oil on wood; L. 171 cm. 64.2101*

from the Middle Ages appear to have been ecclesiastical pieces, for the church was more stable and settled than other institutions of the time. Those intended for domestic use were normally of a size two people could carry. American examples in both English and German traditions are typically about two feet deep, about as high, and little over twice as long. They could easily be moved through doorways and placed against a wall without protruding too far into the living space. Their primary use was as containers but they also served as display surfaces and in some cases they might have been used as seating furniture. These elongated boxes were usually raised on feet of some sort to protect the objects inside from dampness and, although dampness is not the problem it once was, the piece usually remains conceptually incomplete without feet.[51]

The interior of the chest contains unspecialized space, a traditional aspect modified in later forms. As anyone who has used a chest can testify, only an approximate organization is possible within it; save for the till in some examples, the interior space is undifferentiated. Objects, usually textiles, are piled one on top of the other. Unless one has the foresight to pile them in exactly the order they will be needed, it is necessary to remove many things from the chest each time one wants to retrieve a single item.

The chest of drawers, which alleviates this storage problem, is an entirely different concept and a much later development

74

Fig. 83. *Salt box decorated by John Drissel,*
upper Bucks County, Pennsylvania, dated 1797.
White pine, painted decoration; H. 28 cm.
58.17.1

in the history of furniture. It appeared in England in the early seventeenth century and probably later in Germany. While the chest might be considered folk the chest of drawers was introduced as a middle-class object. It was not tradition from the bottom up by any means.[52] In a chest of drawers, space is organized much differently. One does not gain access to material by lifting the top but by drawing out a spatial unit about the same depth and length as the chest but only a few inches high. Instead of the deep, undifferentiated space of the chest there are several of these smaller, more horizontal spaces. In the New England chest in figure 63 there are four such drawers. Because each is relatively shallow, the need to sort through or remove items to locate the object sought is minimized. Division of the space into vertically arranged horizontal segments makes possible a system of accessible storage impossible in the traditional chest. This specialization is a move away from the

Fig. 84. *Tape loom decorated by John Drissel.*
Upper Bucks County, Pennsylvania, dated
May 2, 1795. Painted white pine; H. 44.5 cm.
59.2812

75

Fig. 85. *Fireboard, possibly Sutton, Massachusetts, 1830-50. Oil on white pine; H. 67.3 cm. 67.1859*

crowded multipurpose space and multifunction objects of the Middle Ages toward the specialization of space and purpose which reaches its peak in America in the nineteenth century.[53]

The chest had extraordinary longevity in parts of the German-American community. Its life in the Anglo-American sector was more limited; there the form became less common after the end of the eighteenth century. But the chest of drawers did not immediately or totally supplant the chest. Not only was the shift over time gradual, but with it took place one of those striking instances of assimilation and accommodation of which the human mind is capable.[54] The chest and chest of drawers represent polar extremes: new and old, progressive

Fig. 86. Left, *molded* Hansel und Kretel *plate, attributed to David Spinner. Milford Township, Bucks County, Pennsylvania, 1800-1810. Red earthenware, white slip and sgraffito decoration, clear lead glaze; Diameter 30.5 cm. 60.652. Right, thrown plate, Jacob Joder pottery mark. Probably Berks County, Pennsylvania, dated 1810. Red earthenware, white slip and sgraffito decoration, clear lead glaze; Diameter 30.9 cm. 60.688*

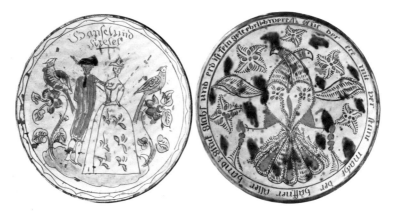

Fig. 87. *Dish, Conrad R. Ranninger. Montgomery County, Pennsylvania, dated June 23, 1838. Red earthenware, white slip around leaves, splashes of green, clear lead glaze; pottery mark Diam. 24.6 cm. 67.1612*

and conservative, specialized and unspecialized. Because of this people developed an intermediary step or compromise solution which preserved the salient feature of each alternative.

The reconciliation of the poles, perhaps a form of the resolution of cognitive dissonance, took the form of a chest that also contained drawers. One type of chest with drawers produced by Pennsylvania Germans retained the appearance of a chest (Figs. 60, 61). Another solution common in New England and Long Island is shown by the chest with drawers dated 1742 and presumably made in Taunton, Massachusetts (Fig. 69). This is a different combination of two ideas preserving much of the appearance of a chest of drawers. It is almost as high as it is wide and the front is divided into three horizontal surfaces which look like drawers. Only the lower two are functioning drawers, however. The upper section still conserves the old idea of a lift-top chest. The front surface of this piece of furniture has been adorned with a fluid design of birds and

Fig. 88. *Covered jar, Piedmont area, North Carolina, 1800-1830. Red earthenware, white slip-trailed decoration, splashes of green, clear lead glaze; H. 26.7 cm. 61.1134*

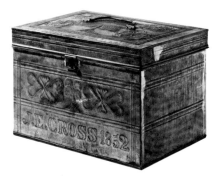

Fig. 89. *Box with punched decoration, probably Pennsylvania, dated 1852. Tinned sheet iron; H. (including handle) 27.9 cm. The willow tree decoration was commonly used as a mourning motif.* 65.1437

Fig. 90. *Flesh fork, attributed to Peter Eisenhauer. Hereford Township, Berks County, Pennsylvania, dated 1776. Steel, uncised decoration, inlaid brass inscriptions; L. 38.2 cm.* 60.792

generous compass-generated vines which flow smoothly over it, disguising the two very different concepts of storage inside. Other examples carry the similarity to a chest of drawers even further, with the entire facade so arranged, shaped, and decorated as to deceive at first glance. The upper two drawers continue to be false, concealing the persisting appeal of the lift-top chest.

The chests with drawers indicate how the idea of tradition is relative and varies from object to object and from context to context. Compromise solutions can become themselves traditional in regions. In Pennsylvania-German areas a low chest with drawers visually similar to the chest form perpetuated a traditional form. In New England and Long Island, on the other hand, the chest with drawers solution resembled the chest of drawers and seemed more innovative than it was. In one case a new idea wears an old costume; in the other an old idea wears a new one. The objects demonstrate how a conservative society may assimilate innovation and a progressive one accommodate continuity.[55]

Tradition helps to determine whether an object can be termed folk art but other factors may be more influential. The requirement of a certain obvious expenditure of "blood and treasure" disqualifies highly traditional objects like ladder- or slat-back chairs. This type of chair can be traced back at least as far as the seventeenth century nearly unaltered. Ladder-backs have been made in this country since the earliest days of English settlement and have remained in production, with little or no interruption, until the present. Textbook examples of traditional folk artifacts, they have changed little over time, surviving outside of the fluctuating patterns and styles of chairs of both popular and elite culture. Yet scholars and collectors have disregarded these chairs, probably because they are plentiful, ordinary, and inexpensive. The collectors' standards rather

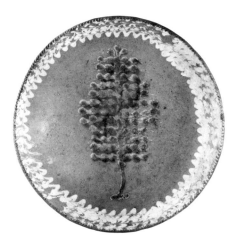

Fig. 91. *Dish, Pennsylvania, 1820-50. Red earthenware, slip-trailed decoration, splashes of green, clear lead glaze; Diam. 40.4 cm. 67.1506*

Fig. 92. *Dish, American, 1810-40. Red earthenware, color slips to produce "marbling," clear lead glaze; L. 34.6 cm. 65.2316*

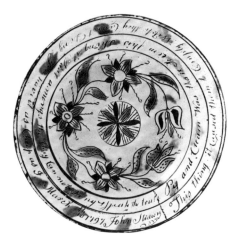

Fig. 93. *Dish, possibly by John Strawn. Probably Bucks County, Pennsylvania, dated March 10, 1797. Thrown red earthenware, white slip, sgraffito decoration, clear lead glaze; Diam. 36.5 cm. The dish is unusual because the inscription is in English. 65.2302*

Fig. 94. *Water cooler or keg, C. Goetz, Smith & Jones, Slago Pottery. Zanesville, Ohio, ca. 1850. Yellow earthenware, brown slip-trailed and relief-molded decoration, clear lead glaze; pottery marks; H. 40.4 cm. Originally the cooler had a lid. The eagle motif was made from a mold taken from a pressed glass salt of a pattern attributed to the Boston and Sandwich Glass Company. The cooler supposedly was made for the Eagle Hotel in Zanesville. 59.2188*

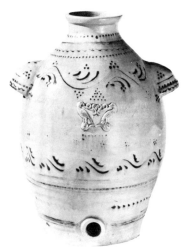

than the new historians' have dictated the direction of artifact study.[56]

A traditional object which is relatively rare has a better chance of being accepted as folk art. This might qualify the Pennsylvania-made chair, nearly indistinguishable from its German antecedents and counterparts not only in its design and conception but even in the seemingly insignificant details of construction (Fig. 71). Although conceived in one context the chair was recreated in a second context which had no significant impact on it. Yet the cult of the unique means this object is unlikely to be accepted as folk art. While traditional like the ladder-back chair, it is also a replication of a common model and not unique enough nor distinctive enough to be called folk art. Since it is virtually inseparable from German examples it also violates the myth of national uniqueness. The piece is not a thrilling enough objet d'art to compensate for this violation.

While tradition is necessary for folk art, it is not sufficient. Keeping the emphasis on art, variations on tradition are usually more valued than tradition itself because they meet more readily the requirements of novelty, uniqueness, and innovation. The kind of innovation acceptable in folk art is conciliatory invention, the combination of current and earlier ideas to create an object which reconciles the past and the present. A chair made by one of the Dunlaps in New Hampshire in the late eighteenth century demonstrates the contradictory demands for tradition and innovation present in conciliatory innovation (Fig. 72).[57] Two very different chair concepts and two stylistic alternatives are reconsidered in one soft-maple chair. The designer combined the feeling and configuration of the Chippendale style with the proportions and scale of the earlier and more familiar William and Mary style.

A chair like the Dunlap chair may generate two different explanations. On one hand is the notion that it was produced by an inept rural craftsman incapable of replicating the high style designs. The product falls short in a number of obvious, accidently amusing ways.[58] This view recapitulates the condescending notion that the folk are simple souls whose work is a well-meaning if incompetent attempt to rival high style rather

80

than a viable cultural alternative. But this Dunlap chair abounds in evidence of intention rather than accident. The workmanship of this and other Dunlap pieces shows that the craftsmen had full control of their tools and were capable of making the hand carry out the mind's vision. In interpreting an urban mode in their own terms they made several adjustments to make the new object comfortably familiar while simultaneously adapting the old elements to suit recent changes in taste. The William and Mary "feeling" is suggested by retaining the back of the chair at forty-five inches, the average height for a William and Mary chair of half a century earlier, instead of matching the usual thirty-eight-inch height of a Chippendale chair. The seventeen-inch-seat width in William and Mary chairs was increased to the more typical and probably more comfortable twenty-one inches common to Chippendale chairs. These modifications indicate that the chair is the result of conscious decisions and is not simply an attempt at imitation that failed.

The other explanation for objects like the Dunlap chair comes from the nationalists, who translate what the elitists see as failures into triumphs of the American character. To them, this chair proves its superiority by refusing to ape elite culture, which is only unreflective fawning over imported European taste. In rising above European material, the Dunlaps and others like them demonstrated their own new or personal vision. Imitation of European models shows a slavish adherence to the trappings of a degenerate European aristocratic society totally alien to a free, republican American.

Both the elitist and nationalist views distort the object and its place in the subculture that produced it. Instead of studying an object for what it might reveal about man, they have exploited folk art for their own ends.[59] They have failed to recognize that the Dunlap chair, like many other pieces, is neither the work of an incompetent nor a nationalistic zealot but of an artisan who adjusted ideas to fit his own needs and those of his customers.

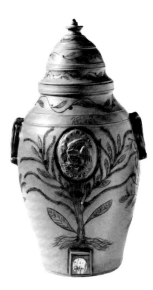

Fig. 95. *Water cooler or keg, America, dated 1853. Gray stoneware, cobalt-filled incised designs, relief decoration, salt glaze; H. 66 cm. The name T. Whiteman incised in one side may be that of the owner or maker.* 59.1926

Fig. 96. *Bowl, attributed to Caln Pottery of Thomas Vickers and Son. Near Downingtown, Pennsylvania, dated 1806. Red earthenware, white slip, sgraffito decoration, green glaze; H. 11.4 cm. Made for Rachel Heston, whose name appears on the reverse.* 67.1593

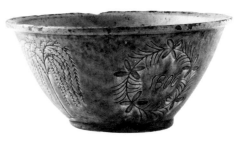

Fig. 97. *Mug, John Bell. Waynesboro, Pennsylvania, 1840-65. Buff earthenware, brown decoration, clear lead glaze; pottery mark; H. 10.8 cm. the dendritic or mosslike designs of this mug were inspired by English mocha ware. 60.556*

DECORATION

Decoration is a prerequisite of folk art. There is little theoretical written about its role in folk art but patterns can be found in de facto definitions. The prevailing notions of American folk art are based on relatively conservative definitions of fine art and do not follow the ethnographical approach to folk material culture developed in Europe around the turn of the century. By the 1920s the Germans were publishing comprehensive surveys of regional *Volkskunst* which embraced ecclesiastical, secular, commercial, and agricultural buildings, funerary and religious monuments, interiors, furniture, metals, ceramic vessels and tiles, carvings, painted objects, and costumes.[60] For his 1932 exhibition of American folk art at the Museum of Modern Art, Holger Cahill assembled 175 objects he considered equivalent to the painting and sculpture of American elite culture. In contrast to the European approach to material cultural he included oil paintings, pastels, watercolors, paintings on velvet and glass, wood sculpture, sculpture in metal, and plaster ornament. In taking this direction Cahill contributed to the breach between those who study folk art—a group largely made up of collectors, dealers, and art museum personnel—and those who take an ethnographical or historical approach to material culture—university scholars and historical and anthropological museum staff. Consequently, the study of folk art has existed without a rigorous conceptual structure.[61]

The folk art group has argued that these materials should be perceived as art. Cahill's notion that folk art means objects parallel to fine art is retained today. Items defined as painting or sculpture dominate both *Masterpieces of American Folk Art* and *The Flowering of American Folk Art*. The latter publication divides its material into "Pictures: Painted, Drawn and

Fig. 98. *Detail of plate VII showing hood of Paul tall clock and maker's signature.*

82

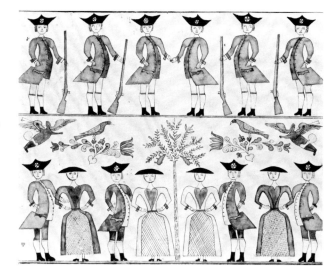

Fig. 100. *Drawing, eastern Pennsylvania, 1800-1820. Watercolor and ink Fraktur; H. 33.3 cm. This may be of Mennonite origin.* 61.1124

Stitched," "Sculpture in Wood, Metal, Stone and Bone," "Decorations for Home and Highway," and "Furnishings." The last two categories are misleading, however. Within the division of "Decoration for Home and Highway" all objects parallel either painting or sculpture, repeating the tendency to project contemporary standards and aesthetic hierarchies onto objects and cultures from the past. Of the forty-seven objects in this category, most are extended forms of painting known to and practiced by artists within the elite tradition: five painted cornice boards, nine painted overmantels, eight painted fireboards, twelve painted or stenciled walls or floors, four painted barns, and four painted tavern signs. Sculpture is thinly represented by two gates, two signs, and a figure from the top of a Masonic Temple in Mendocino, California.[62]

Fig. 99. *Man on a dog, America, 1860-1900. Red earthenware, partial brown glaze; H. 23.6 cm. This figure represents the "off-hand" tradition of the commercial sewer pipe potteries of the late nineteenth century. Factory workers occasionally used the crude sewer pipe clay to fashion objects for their own enjoyment.* 67.1885

83

Fig. 101. *Drawing, possibly Pennsylvania, 1810-1825. Watercolor and ink; L. 31.8 cm. 61.47*

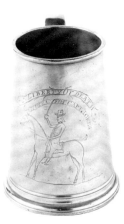

Fig. 102. *Mug, attributed to William Will. Philadelphia, 1765-76. Pewter; H. 14.6 cm. Presented to Peter Ickes. 67.1369*

In the category of "Furnishings" the same bias operates. Of the fifty-five examples of furniture illustrated every one is painted. Chairs are the most common form of furniture but not, apparently, of folk art since only three examples are shown. Most of the other furnishings might be called paintings in spite of themselves: painted tinned sheet-iron, painted and sgraffito decorated ceramics, and quilts. A few others are treated as surrogate sculpture: pie crimpers, a bootjack, and cakeboards.

The same mode operates at the Abby Aldrich Rockefeller Folk Art Collection. In a little booklet recently published describing the collections the usual distribution appears.[63] Seventeen of the illustrations are of conventional paintings or analogous two-dimensional creations, seven meet the folk art populizer's requirements for sculpture, one might be considered interior decoration, and the remaining two are of other household artifacts.

The text accompanying an illustration of a quilt top, stoneware jug, painted oval box, painted coffeepot of tinned sheet-iron and a few other objects noted that it had recently been decided to expand the collection to include "well-crafted decorative household items where the artisan's involvement in fashioning an object resulted in an aesthetically pleasing personal artistic expression."[64] Here again decoration is part of the criterion for identifying folk art.

The emphasis on decoration provides insight into the relationship between folk art and modern art. While there is a historic link between them, the two movements have gone different ways. Those familiar with the history of modernism

84

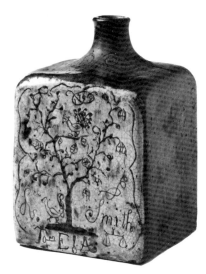

Fig. 103. *Tea canister, by or for L. Smith, Wrightstown, Pennsylvania, dated 1769. Red earthenware, white slip, sgraffito decoration, splashes of brown, lead glaze; H. 21 cm. A similar canister was made in 1767 for Esther Smith. 57.1390*

know that decoration was rejected early by the modern movement because it suggested a degenerate, materialistic, parvenue class and unrestrained conspicuous consumption. The rejection of decoration is perhaps best summarized in the famous dictum: "Less is more."[65]

The folk art popularizers have kept alive a much older idea of what makes an object worthy of visual attention: art is found in the extra decoration added to an object, that additional element which goes beyond necessity. If an object passes beyond the mere fulfillment of a physical need, it rises to the status of art. Objects, however, do more than fulfill physical function; there is no such thing as a purely functional solution. The limitations of human creativity and man's tendency to repeat familiar patterns work against that.[66] The objects called folk art usually bear enough decoration to eliminate any possibility of mistaking the object as a direct or efficient solution to a technical problem.

This conservative stance has persisted in the selection of objects called folk art. Most are still a variation on the theme of painting or sculpture. The folk art rhetoric tends to take an art-for-art's-sake stance toward these phenomena, further removing them from any contact with the hard and homely reasons for existence. In a recent catalog of Georgia folk art, a pine huntboard, a painted cupboard, a hair wreath under glass in an oval walnut frame, a punched-tin door, canes, a doll-size rattan chair, and four baskets, the latter rather utilitarian look-

85

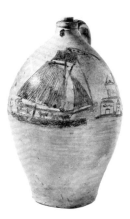

Fig. 104. *Jug, probably mid-Atlantic region 1810-40. Gray stoneware, cobalt-filled incised design, salt glaze; H. 44.1. This is the only jug known with a landscape scene. 57.549*

Fig. 105. *Detail of figure 104 showing buildings incised on jug. The main house and smokehouse are on the opposite side.*

Fig. 106. *Jug, possibly New York state, dated 1800. Buff stoneware, cobalt-filled incised decoration; salt glaze; H. 18.4 cm. The initials J.R. incised on the other side may be those of the maker.* 59.1098

ing by most standards, were assembled with other items under the heading of "sculptural objects."[67] The idea persists that by removing the object from the taint of use it will be elevated to the level of art.

Another index of the folk art movement's relationship to modernism can be seen in the treatment of the Shakers. Perhaps because there is no widely shared single definition of folk, there is disagreement about whether or not the Shakers qualify as folk. Some definitions of folk demand an unawareness of being different that the Shakers did not possess. The Shakers were intentionally different. Consequently, they are seldom studied by folklorists and frequently studied by historians of religious and utopian communities. Their material culture has been divided and studied by different groups. Shaker furniture is part of "nineteenth-century modern" and exhibits the aesthetic qualities stressed by the modern movement; simplicity, even austerity, and the absence of decoration.[68] What appear in discussions of folk art instead are the relatively rare and atypical spirit drawings. These are bright, expansive, if often cryptic, images allegedly based on divine revelations. Employing strongly stylized forms and being an extended form of paintings, these works fit the conventional requirements for folk art.[69]

One could hardly ask for a more clear-cut example of the way people ransack the past for objects which support their biases than is provided by the disparate treatment of the Shaker materials. It occurs because age lends credibility and legitimizes. To have a tradition and a history are important psychologically and socially because longevity impresses people. To validate two different sets of aesthetic and social inclinations, Shaker material culture has been severed into unrelated units. This division does little to further our understanding of the Shakers, but much to support the positions of two different factions.

The emphasis on decoration in folk art insures that when two similar objects are available, one plain, the other painted, the latter will be pronounced art while the former will be labeled another dull example of the form. If a salt box or tape loom is decorated enough to become painting, then it can be

86

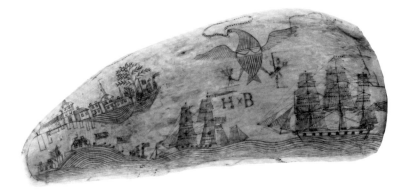

Fig. 107. *Scrimshaw, America, 1825-60. Whale tooth; H. 21 cm. An unusually detailed combination of land and sea. 67.862*

called folk art (Fig. 83, 84). This notion that the unadorned object cannot be art is a long-standing idea. When objects are evaluated by this system, the premises that underlie their creation are disregarded. This approach tells people that their own value system is erroneous or inverted. In claiming that art is really only painting and sculpture, folk art writers fail to acknowledge that the appeal of an object may be in its shape, color, balance, symmetry, proportion or in tactile rather than visual values. They also evade the fact that an artifact is not an end in itself but a means. They are not made to *be* but to do: to perform work, to preserve or falsify images, to confer status, to meet psychological needs.

A quilt may be a means for social interaction. In a study of a quilting party which took place during the summer of 1974 in rural northern Louisiana, Susan Roach attempted to understand the function of a quilt in context.[70] She perceived a variety of functions. Some were obvious, like providing warmth when a power failure shut off electric blankets. Other functions were more subtle. The quilting bee provided a structure for social interaction and displays of skill or competence. Some of the participants were experienced in needlework, others were novices. Inferior performances were acknowledged and accepted.

Susan Roach's findings are strong argument for the irrelevance of the concept of art. The quilters recognized differences in their competence, but this was only one factor and by no means the dominant one. Whether the quilt they produced would have passed muster as folk art in the judgment of folk

87

art specialists is unknown but that judgment is irrelevant to the role of this quilt.

Ceramics are one category which has been largely ignored by the folk art people. They are just beginning to be collected as folk art. How have these objects, once not considered folk art, changed? One answer is that they are now worth a lot of money. Another is that they meet more flexible requirements of being extended forms of paintings and sculpture.

Free-standing ceramic figures have sometimes been included in the category of folk art. But most ceramics are too explicitly directed toward a mundane, physical function to suit the conceptions of art. Those that are accepted meet the criteria for additional decoration beyond necessity. As with the other categories of folk art, there is little or nothing typical about the ceramics accepted as folk art; all are in one way or another extraordinary objects.

Sgraffito plates are likely to be defined as folk art. They meet the requirement of tradition, although it is not always clear whether it is a German or English tradition that they perpetuate, since the technique was employed in both countries. They were produced by a relatively difficult and time-consuming process as part of what could be called the "top of the line" of an earthenware potter's products (Fig. 86).[71] If sgraffito plates are uncommon, sgraffito hollowware forms are more unusual; a jar dated October 5, 1788, is a very atypical object.

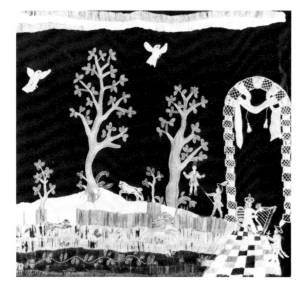

Fig. 108 *Needlework picture of Joab slaying Absalom, Boston-Salem area, Massachusetts, 1760-1780. Silk fabric, silk yarns, human hair (on Absalom), paint (on faces); H. 51.4 cm.* 59.1844

88

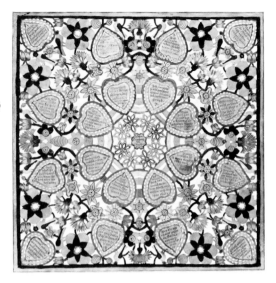

Fig. 109. *Cutwork love letter, signed Adam Dambach. Lancaster, Pennsylvania, 1779. Watercolor and ink Fraktur; H. 31.4 cm. by sight. 65.1339*

Ceramics often show the marriage of tradition and horizon in a particularly sharp light. Normally tradition lingers in the form, horizon appears in the decoration. An earthenware bowl with an orange-brown glaze on the inside and mottled yellow-green on the outside shows this combination (Fig. 96). The shape perpetuates a form introduced to the western world from the Orient centuries earlier. Made over the years in many different bodies, the form would be difficult to date were it not for incised clues: the date of 1806 in a circular wreath, a willow tree, and other motifs. Even without the date, the wreath and the weeping willow would make this object recognizable as a product of the early nineteenth century.

In many categories of American ceramics, the undecorated article is the most typical. Concave dishes of various sizes are common: examples with large trees of white slip splashed with green (Fig. 91) are not, nor are pieces with natural leaves surrounded by white slip (Fig. 87). Glazed covered jars can be found with relative ease but jars with colored bands (Fig. 88) cannot. Stoneware jars and jugs were ubiquitous in the last century, but those with animals incised into the body or painted on the surface are harder to find and more expensive (Fig. 11). A stoneware jug with a ship and a landscape scratched into the body is rarer still (Figs. 104, 105). And so is

89

Fig. 110. *Needlework mourning picture, Lucy Nye. Probably northern New England, 1810-1820. Silk embroidery on cotton, paper inserts for tomb and signature; H. 28.6 cm. 64.775*

another stoneware jug from the early nineteenth century which bears the impressed inscription "G. WASHINGTON / FOR. EVER" and a number of impressed circular devices surrounding the applied relief portrait not of George Washington but of Jesus Christ (Fig. 74).

In these ceramic examples, tradition is present in the forms themselves and in the decorating techniques employed, for all are highly conventional ways of decorating clay objects and have been employed for years. The decoration tends to be conceptually distinct from the object, mentally separable. Only a single step of decoration separates the typical ceramic object from the folk art object. The decoration of ceramics, however, usually shows a conceptual complexity which is on a very modest level.

COMPETENCE

A small stoneware jug or bottle about seven inches high is like many objects except for some initials, a date, a flowing plant, and a strange-looking creature, perhaps a mermaid, incised into the body and filled in with blue (Fig. 106). It is not merely that this object is decorated, but the nature of that decoration causes it to be considered as an example of folk art.

90

The figure is a curious, asymmetrical creation of someone whose approach seems to have embodied the carelessness parodied in the familiar "plan ahead" sign where the last few letters are jammed together for lack of forethought. It has the look of having been quickly and impulsively scratched into the surface of the soft clay before the piece was fired. Symmetrically arranged, it is nonetheless asymmetrical. One leg (or is it a tail?) is broad, one is thin. One arm is longer and fatter than the other. The result is a loosely defined unidentifiable creature.

On a small earthenware dish, the figure of a man smoking a pipe has been trailed in light slip (Fig. 111). The figure's head is larger than any other part of his body. Indeed, it is difficult to be certain how much of his body is represented; the form is so vague that the figure appeard to dissolve below the shoulder. With what art historians call economy of means, the decorator seems to tave devoted no more effort to the task than was necessary to define a recognizable figure. That was enough.

In their decoration the jug and plate display a certain elusive quality found in folk art. Writers have had difficulty pinning this down and have suggested that such work is naive, unsophisticated, amateur, childlike, and a number of other analogous terms. No one word is adequate to describe what the French more evasively call this "je ne sais quoi."

While there is no familiar term in the vocabulary of art for what we are talking about, the study of linguistics provides the terms competence and performance. Competence might be defined as a system of rules that characterize an individual's knowledge or understanding of how something is done. Performance refers to a person's ability to execute or carry out this system.[72] In general, competence exceeds performance. People rarely do anything as well as they know how.[73] These terms apply to folk art. Most of those objects identified as folk art have been selected because they appear to represent modest levels of competence and performance. This notion incorporates all the possibilities included in the art terms listed above yet avoids their condescension and limitations. This does not mean that all objects made in folk societies display only modest competence or that the folk are necessarily limited in their abilities but rather that the objects called folk art have

Plate VI. *Unidentified man, attributed to Jacob Maentel.*
Probably Reading, Pennsylvania, 1825-1835.
Watercolor; H. 31.5 cm. 57.1112

Plate VII. Kiche Schrank (*"kitchen cupboard"*), Pennsylvania, 1800-1830.
Painted wood. H. 214.3 cm. 64.1897

Fig. 111. *Dish, probably Pennsylvania, 1820-60. Red earthenware, slip-trailed decoration, clear lead glaze; Diam. 17 cm. The pipe-smoker is an unusual theme in American slipware.* 59.2252

been selected because a certain level of ability or intention was intuited to their makers. Some objects are rejected as folk art because they seem to be done too well. Most folk art looks like anyone could do it.

The folk art drawn from the material culture of the Pennsylvania Germans seems the product of conventionalized modest competence. Although objects are richly decorated, the conceptions of ornament and levels of execution are not on a par with elite culture products; the latter do not fit the society's norms of propriety and decorum. A little watercolor showing armed soldiers on one line and ladies and gentlemen on another is typical of two-dimensional work (Fig. 100). The figure in space is presented as a conceptual rather than visual reality. Elements which are obvious enough parts of our visual and physical world but irrelevant to the maker are neither recorded nor suggested. The figures stand flat, with no modeling, against a totally unrelieved page. There is no indication of setting. The page is not a perpetuation of the Renaissance concept of a window on the world but a flat paper surface. The idea of figure is more important than details; the figures are as similar as they can be made by the "workmanship of risk,"[74] without using patterns or stencils. One row of figures is above another because their creator put them there. As in illuminated manuscripts of the Middle Ages and children's drawings, idea takes primacy over a physical reality like gravity. Economy of means is present too. Each face has been drawn using an efficient system which involves only four steps: 1) an approximate semicircle defines the face; 2) a cursive V creates both the eyebrows and the nose; 3) two ovals become eyes; and

94

4) a wavy line the mouth. The same system is repeated in each figure. Birds, angels, and trees are all subjected to the same process of reduction to become efficient conveyors of visual meanings.

Similar economies appear in another small watercolor and ink drawing inscribed "We are going to Attend Sunday School and Shun bad company, to day" (Fig. 101). Most of the paper is filled with rows of tiny heads piled like apples or oranges on display. The figures are clothed in black with white collars. Some face right, some left, but most look forward through round black eyes. Heads are oval. Cheeks are circles of red. Hair is a curly line and the eyebrows and nose are made by that same running V.

The academies founded to promote art had as one of their goals the elimination of the need for each creator to reinvent schemata for representation. Joshua Reynolds said, for example, that without standing on the shoulders of those who had gone before them, artists would be consigned to repeat the errors of their predecessors and never pass beyond their achievements.[75] One might colloquially say that they would reinvent the wheel each generation. This in many ways is what the folk artist does. Regardless of who made them, and whether the objects are those "unique" artifacts so sought after or those which exhibit learned traditional forms, works called folk art seem to reflect solutions closer to the beginning of possibilities than to the end. Because the category of folk art includes objects from many different contexts, the causes for this vary. In some cases time, being money, was a factor. In others, the object was the product of a child or adolescent who was learning a schema. In many other cases greater competence was neither necessary nor valued. Sometimes it was not possible.

The modest competence within folk art has often been described as childlike. Considered as a descriptive rather than a pejorative term, this has value. Several participants in the symposium devoted to American folk art in *Antiques* in 1950 noted this quality. John Baur observed that the quality of folk art rarely sank below or rose above what he called "a certain middle range of expressive power." E. P. Richardson insisted

that part of what is called folk art was either amateur work or "the product of the child within us. Untrained adults who try their hand at copying nature or another work of art begin at the childish level." Erwin O. Christensen made the point even more emphatically. In examining a small carving of a group of figures, he noted that the workmanship was only one step "removed from carpentry. Like most adults who are artistically untrained, the carver falls back on infantile forms when attempting the human figure. Though it is put together with more than a child's competence, this toy-like construction shows a partial regression to childhood. Folk art is here close to child art; one might say that folk art is child art on an adult level."[76]

In their book on folk art in the twentieth century, Herbert Hemphill and Julia Weissman address this same point, arguing that people who commence painting or carving when they are mature do not produce work like their practiced peers, but start at the beginning, as a child might.[77] Some continue to pass through levels of development and their work becomes more empirical and responsive to conceptions of reality dominant in the adult world. Others lack motivation or impetus for change and the individual continues to create his own egocentric absolute reality, although through repetition that performance may become highly refined.[78] This is the case for painters called folk like Edward Hicks, Joseph Maentel, and Grandma Moses.

That folk art is childike is an idea which has still not been fully developed. The idea is not new. Nearly fifty years ago Henri Focillon dealt with the same matter in his introduction to *Art Populaire*. Focillon described children, primitives, and folk artists as those who "conceive before they see. Representation of images, in their case, is dominated by rationality (as against empiricism) and by a powerful instinctual need for order." Focillon maintained that folk art points out the "profound accords between peoples, derived from both an extremely ancient community of man and a natural, general aptitude of man."[79] The idea is a more graceful statement of the old notion that ontogeny recapitulates phylogeny: all humans as they develop pass through the general development of the species.

Although conditioned by each society and culture, the growth of the mind, like the growth of the body, seems to be potentially similar for all people.

Focillon's perspective explains how it is still possible for there to be folk artists in the twentieth century when, as Robbins argues, there are no more folk. The anthropological definition of folk according to social characteristics becomes irrelevant, and consequently the need to explain the seeming paradox of the highly sophisticated development of a given artisan, the chairmaker Charley, working within what seems to be a folk tradition also becomes irrelevant. The intellectual level identified as folk can be found in any context. Calling it childlike does not demean but only identifies aptitudes developed by most people by the age of twelve or so. There are in fact, differences between folk art and children's work, particularly in performance, where a schema only used haltingly and imperfectly by a child might be employed with perfection by an adult. It still, however, will be a competence of modest level that is externalized.

Like the products of children, folk art is beginning to attract scholars because it seems an accessible route for exploring the workings of the mind. And those workings are exciting. It is fascinating to watch someone grope toward a solution to a problem, feeling their way towards externalizing an internal mental structure. Lucy Nye, if she is the person who made the needlework picture with that name on it (Fig. 110), was dealing with a set of problems with which anyone can readily identify. How, without being taught the rules of perspective, does one make a checkerboard floor recede into space? How, without being instructed in the conventions for depicting trees, does one make a tree seem to branch? How, without taking lessons from a drapery painter, does one create the illusion of a shawl moving over three-dimensional forms and backward and forward in space? How, without being privy to the shared conventions of floral painters, does one depict a vine, and how does one depict a songbird in flight when they move so fast one cannot even see them clearly? Seeing evidence of a mind reaching toward mastery of representation provides an excitement quite different from a master technician's sure and flawless

manipulation of his materials. To some it is preferable. As the twentieth-century painter Paul Klee put it, "Becoming is more important than being."[80] Lucy Nye's solutions are approachable. People can identify with them for they might reach similar solutions in similar circumstances. Part of this approachability is related to the obvious evidence of the hand in her work. People often claim that because it is handmade, folk art is more personal, expressive, intimate, and immediate than the highly polished or refined products of elite culture or mechanical production. The cult of the sketch has adopted the same language. The sketch is claimed superior to the finished drawing or painting because it brings us closer to the artist. There is less time and mental distance between the idea in the mind and its externalization as a sketch than between the idea and the finished work, which is necessarily the end product of a lengthy process of refining and adjusting. Folk art seems, like a sketch, to be closer to the initiating mental impulse.

The other explanation for the approachability of folk art centers on competence. Those accomplishments which go beyond average competence or performance bring respect and admiration. But those that are inferior may subconsciously evoke nostalgic feelings of childhood or the protective feeling of a parent to its child. If this is true, it explains the enduring appeal of these objects. However, although it may be related to the intellectual development of the child, it is not necessarily simple. Consider human creativity as a tree. The manifestations of various highly trained or distilled elite traditions are near the ends of the branches. Folk art, however, develops nearer the trunk and closer to the intellectual development of mankind in general. It is less affected by cultural concerns. But this location does not make it therefore simpler. In fact, the refined products near the branch's ends may be easier to explain, for folk art's position only brings it closer to major unanswered questions about the operation of the mind.

In specific terms, Trent has tried to outline the subtle complexities of seemingly simple chairs. Jones has analyzed the wide variety of factors influencing the appearances of chairs made by a single individual. Glassie has attempted a structural analysis of a related group of seemingly simple houses to

98

demonstrate that the competence they displayed was highly complex, involving the mastery of many interrelated rules. Glassie was able to unravel these rules and reconstitute them in verbal form. Although he did not work to the same purpose, James Agee perceived similar rules governing house design in Alabama.[81] If forced to build their own houses most people in this society might follow some of the same rules. Similarly, folk art is not so much simple as based on widely shared capabilities.

In conclusion, it is appropriate to evaluate the impact of folk art on twentieth-century life. In part it has been negative. Folk art has been used by a small but vocal faction against the rest of society and exploited as a means to personal and financial aggrandizement. There is the hope, however, that in the long run its contributions will be positive. First, although it has not always been the intention of some of the people involved, folk art may help to extend the limits of the man-made world considered worthy of attention. Because of the inevitable link between objects and people it may increase the tolerance for diversity and variety in others. Perhaps it will be possible eventually to show that the interest in folk art was a step away from prejudices against objects and people and toward a belief that all people and the things they make and do are worthy of serious attention.

Secondly, folk art may teach us that objects produced without the investment of excessive "blood and treasure" can still be intensely satisfying. Great cost is not necessary for enjoyment. Objects which can gratify and add a dimension of enrichment and a significant experience to life are available not only to the affluent. Pecuniary worth is not the only yardstick for value.

Thirdly, folk art may become the focus of important intellectual activity. It has been defined, redefined, and approached from many different points of view and has already been the catalyst for work on the cutting edge of material culture studies. The best recent work, by people like Glassie, Jones, and Trent, has used folk art as an avenue of inquiry into the workings of the human mind. This seemingly simple topic has already become the subject of lofty thought.

99

NOTES

1. Holmes, *The Professor at the Breakfast-Table* (Boston: Houghton Mifflin Co., 1886), p. 8.

2. Henri Focillon, Introduction to *Art Populaire* (1931), trans., in Robert F. Trent, *Hearts & Crowns* (New Haven: New Haven Colony Historical Society, 1977), pp. 15-20.

3. Redfield, "The Folk Society," *American Journal of Sociology* 52, no. 4 (Jan. 1947): 293-311; Redfield *The Primitive World and Its Transformations* (Ithaca: Cornell University Press, 1953), pp. 1-25.

4. Glassie, *Pattern in the Material Folk Culture of the Eastern United States* (Philadelphia: University of Pennsylvania Press, 1968), pp. 1-17.

5. Kubler, *The Shape of Time* (New Haven: Yale University Press, 1962), p. 1.

6. Trent, *Hearts & Crowns*, pp. 23-24.

7. Jones, *The Hand Made Object and Its Maker* (Berkeley and Los Angeles: University of California Press, 1975), pp. 14-19, 219-20.

8. David Pye, *The Nature of Design* (New York: Reinhold Publishing Corp., 1964), pp. 7-8.

9. Jones, *Hand Made Object*, p. 241.

10. Gillo Dorfles, *Kitsch, The World of Bad Taste* (New York: Universe Books, 1969).

11. Milton J. Bloch and Charles T. Lyle, Foreword to *Masterpieces of American Folk Art* (Lincroft, N.J.: Monmouth Museum and Monmouth County Historical Association, 1975), unpaginated.

12. Trent, *Hearts & Crowns*, p. 24.

13. Robbins, "Folk Sculpture Without Folk," *Folk Sculpture USA*, ed. Herbert W. Hemphill, Jr., (Brooklyn: Brooklyn Museum, 1976), pp. 14-16.

14. Trent, *Hearts & Crowns*, pp. 29-90.

15. Jean Piaget and Bärbel Inhelder, *The Psychology of the Child* (New York: Basic Books, 1969); Albert E. Scheflen, *How Behavior Means* (New York: Jason Aronson, 1974); B. F. Skinner, *Beyond Freedom and Dignity* (New York: Knopf, 1971); David M. Potter, *Freedom and Its Limitations in American Life,* ed. Don E. Ferenbacher, (Stanford; Stanford University Press, 1976).

16. Philip M. Isaacson, *The American Eagle* (Boston: New York Graphic, 1975).

17. Patricia Hills, *Eastman Johnson* (New York: Clarkson N. Potter, 1972); Milton E. Flower, "Schimmel the Woodcarver," *Antiques* 44, no. 4 (Oct. 1943): 164-66. For a later publication by Flower with little new information, see *Wilhelm Schimmel and Aaron Mountz, Wood Carvers* (Williamsburg: Abby Aldrich Rockefeller Folk Art Collection, 1965).

18. Thorstein Veblen, "The Intellectual Pre-eminence of Jews in Modern Europe," *Political Science Quarterly* 34, no. 1 (Mar. 1919): 33-42; Robert Ezra Park, *Race and Culture* (Glencoe: Free Press, 1950), pp. 345-92. I am indebted to James Loewen for these references.

19. Audrey and Ed Kornowski, "Statements on Folk Art by Lenders to the Exhibition," in *Masterpieces of American Folk Art,* unp.

20. Flower, "Schimmel the Woodcarver," pp. 164-66.

21. Jean Lipman and Alice Winchester, *The Flowering of American Folk Art* (New York: Viking Press, 1974), p. 180.

22. Keil, *Urban Blues* (Chicago: University of Chicago Press, 1966), pp. 34-38.

23. Keil, *Urban Blues,* pp. 34-35.

24. Keil, *Urban Blues,* pp. 38-39.

25. Mumford, *Technics and Civilization* (New York: Harcourt, Brace, 1934), p. 27. See also David M. Potter *People of Plenty* (Chicago: University of Chicago Press, 1954).

26. Edmund Carpenter, "Statements by Lenders," in *Masterpieces of American Folk Art,* unp.

27. Charles Locke Eastlake, *Hints on Household Taste* (1868; reprint ed., New York: Dover Publications, 1969). The term *rough workmanship* is from David Pye, *The Nature and Art of Workmanship* (London: Cambridge University Press, 1968), pp. 13-24.

28. Veblen, *The Theory of the Leisure Class* (1899; reprint ed., New York: Macmillan Co., 1912).

29. David Ward, *Cities and Immigrants* (New York: Oxford University Press, 1971), pp. 1-38.

30. Ward, *Cities and Immigrants,* pp. 1-38.

31. Jones, *Hand Made Object,* pp. 6-25.

32. Patsy and Myron Orlofsky, *Quilts in America* (New York: McGraw-Hill, 1974), pp. 225-44.

33. John Gordon, Preface to *Masterpieces of American Folk Art,* unp.

34. Harry B. Wehle, as quoted in Alice Winchester, Introduction to *The Flowering of American Folk Art,* p. 9; Gordon, Preface to *Masterpieces of American Folk Art.*

35. Burke, *A Philosophical Enquiry into the Origin of Our Ideas of the Sublime and Beautiful* (1957; reprint ed., Notre Dame: University of Notre Dame Press, (1968), p. 113.

36. Beryl Rowland, *Animals with Human Faces* (Knoxville: University of Tennessee Press, 1973), pp. vii-ix.

37. Keil, *Urban Blues,* p. 38.

38. Agee and Walker Evans, *Let Us Now Praise Famous Men* (1941; reprint ed., New York: Ballantine Books, 1960), p. 14.

39. Fleming, "Seeing Snakes in the American Arts," *The Delaware Antiques Show* (1969), p. 75.

40. Various translated inscriptions compiled by Ellen Denker, Winterthur Museum, 1977.

41. Horst W. Janson, "Monkeys and Monkey Lore," *Art News* 44, no. 5 (July 1947): 28ff.; Rowland, *Animals with Human Faces, pp. 8-14.*

42. Lemons, "Black Stereotypes as Reflected in Popular Culture, 1880-1920," *American Quarterly* 29, no. 1 (Spring 1977): 105.

43. Lemons, "Black Stereotypes," pp. 102-7.

44. Robert Bishop, *American Folk Sculpture* (New York: E. P. Dutton, 1974), p. 10; Robbins, "Folk Sculpture Without Folk," pp. 11-20.

45. Bishop, *American Folk Sculpture*, p. 10; Bishop, "Statements by Lenders," in *Masterpieces of American Folk Art*, unp.; Gordon, Preface to *Masterpieces of American Folk Art*, unp.

46. "What is American Folk Art?" *Antiques* 57, no. 5 (May 1950): 355-62; Glassie, *Pattern, passim;* Nathan Glazer and Daniel Patrick Moynihan, *Beyond the Melting Pot* (Cambridge: M.I.T. Press & Harvard University Press, 1963).

47. James W. Loewen and Charles Sallis, eds., *Mississippi: Conflict and Change* (New York: Pantheon Books, 1974), pp. 6-14.

48. Gordon R. Willey and Philip Phillips, *Method and Theory in American Archaeology* (Chicago: University of Chicago Press, 1958), pp. 11-43; James Deetz, *Invitation to Archaeology* (Garden City N.J.: Natural History Press, 1967)., pp. 59-65.

49. Glassie, *Pattern*, p. 43.

50. Construction data compiled by Neil Kamil and Robert St. George; Lutz Röhrich, *Adam und Eva* (Stuttgart: Verlag Müller und Schindler, 1968).

51. Eric Mercer, *Furniture 700—1700* (New York: Meredith Press, 1969), pp. 38-42.

52. Unpublished research by Benno Forman; Ralph Edwards, *The Shorter Dictionary of English Furniture* (London: Country Life, 1964), pp. 197-212.

53. Siegfried Giedion. *Mechanization Takes Command* (New York: Oxford University Press, 1955).

54. Piaget and Inhelder, *Psychology of the Child*, pp. 4-6.

55. Examples of both forms can be seen in Dean A. Fales, *American Painted Furniture, 1660—1880* (New York: E. P. Dutton, 1972).

56. Glassie, *Pattern*, pp. 228-34; Jones, *Hand Made Object, passim*.

57. Charles S. Parsons, *The Dunlaps & Their Furniture* (Manchester: Currier Gallery of Art, 1970).

58. Jones, *Hand Made Object*, pp. 237-42; Trent, *Hearts & Crowns*, pp. 23-24, 86-87.

59. Focillon, Introduction to *Art Populaire*, in Trent, *Hearts & Crowns*, pp. 15-20.

60. Edwin Redslob, ed., *Deutsche Volkskunst* (Munich: Delphin Verlag, 1923—).

61. Cahill, *American Folk Art* (New York: Museum of Modern Art, 1932).

62. Lipman and Winchester, *Flowering of American Folk Art*, pp. 190-279.

63. Beatrix T. Rumford, *The Abby Aldrich Rockefeller Folk Art Collection, A Gallery Guide* (Williamsburg, 1975).

64. Rumford, *Abby Aldrich Rockefeller Folk Art Collection Guide*, p. 9.

65. The conventional history of the modern movement is well summarized in Nikolaus Pevsner, *Pioneers of Modern Design* Harmondsworth: Penguin Books, 1964).

66. Pye, *Nature of Design,* pp. 8-9.

67. Anna Wadsworth, *Missing Pieces: Georgia Folk Art* (n.p.: Georgia Council for the Arts and Humanities, 1976) pp. 54-74.

68. Herwin Schaefer, *Nineteenth Century Modern* (New York: Praeger, 1970), pp. 140-44.

69. Lipman and Winchester, *Flowering of American Folk Art*, pp. 77, 82-84.

70. Roach, "The Quilting Bee: An Interrelationship between Folk Art and Speech" (Paper delivered at the Annual Meeting of the American Folklore Society, Philadelphia, 1976).

71. Winterthur Museum, Ellen Denker, "Artifacts That Speak for Themselves," Typescript, pp. 3-5.

72. David Elkind and John H. Flavell, eds., *Studies in Cognitive Development* (New York: Oxford University Press, 1969), pp. 67-71.

73. Pye, *Nature of Design*, pp. 10-17.

74. Pye, *Nature and Art of Workmanship*, pp. 7-9.

75. Joshua Reynolds, *Discourses on Art* (London: Collier Books, 1966).

76. "What is American Folk Art?" pp. 355-62.

77. Hemphill and Weissman, *Twentieth-Century American Folk Art and Artists* (New York: E. P. Dutton, 1974), pp. 18-20.

78. Miriam Lindstrom, *Children's Art* (Berkeley and Los Angeles: University of California Press, 1962).

79. Focillon, Introduction to *Art Populaire, in Trent, Hearts & Crowns*, pp. 18-20.

80. Norbert Lynton, *Klee* (London: Spring Books, 1964), p. 26.

81. Trent, *Hearts & Crowns;* Jones, *Hand Made Object;* Glassie, *Folk Housing in Middle Virginia* (Knoxville: University of Tennessee Press, 1975); Agee and Evans, *Let Us Now Praise Famous Men.*

THE CATALOGUE OF OBJECTS

A FOLK SAMPLER

1. Chest of drawers, probably the Hadley area, Massachusetts, 1695-1720. Red oak, white oak, chestnut, pine; H. 114.9 cm, W. 110.5 cm. The painted geometric decoration grows out of the scratch and chip carving traditions and is similar to other Hadley chests. See Fig. 63. 57.54

2. Embroidered and shirred rug, probably New England, 1800-1830. Wool surface, bast fiber backing; L. 140.3 cm, W. 90.2 cm. The circles and stars are folded bias strips sewn to the backing in overlapping rows. The small animals and flowers are embroidered with satin stitches. See Fig. 28. 64.1777

3. Quilt, probably Baltimore, 1854. Cotton, silk, sepia ink details; L. 311.5 cm, W. 270.5 cm. Although some of the twenty-five squares may have been done by Mary Evans Ford, a professional, many are signed, presumably by the various women who stitched and presented them. See Pl. III. 69.571

4. Lion, John Bell. Waynesboro, Pennsylvania, 1840-65. Buff earthenware, brown decoration, clear lead glaze; H. 18.7 cm., L. 21.6 cm. Stamped "JOHN BELL" on rear leg. See Figs. 32, 40. 67.1630

5. Native woman, Pennsylvania, 1850-1900. Tulip, painted; H. 51.4 cm. Used as a counter figure. See Fig. 6. 65.2194

6. Kneeling Indian weathervane, America, 1800-1840. White pine, painted; H. 116.2 cm, W. 99 cm. See Fig. 39. 51.65.1

7. Teapot, attributed to Frederick and Louis Zeitz. Philadelphia, 1875. Tinned sheet iron, iron wire, brass, paint, asphaltum; H. 26.7 cm, W. 23.8 cm. "James H. Robbins / Philadelphia" (scratched on the bottom) was undoubtedly the owner. The flower filled medallion on each side is similar to that on other wares by the Zeitz brothers. See Pl. II. 65.1599

8. Eagle, America, 1775-1875. White pine, painted; H. 43 cm, W. 92.5 cm. A hole running vertically through the body indicates this may have been used as a flagpole ornament. See Fig. 34. 59.2371

9. Blanket chest, Lehigh County, Pennsylvania, 1788. Tulip, painted decoration; H. 72.1 cm, W. 127 cm. Inscribed "Margaret / Kernan / 1788" on the center panel. The floral decoration on all three panels is a careful copy of a Fraktur design by Heinrich Otto. See Fig. 60. 59.2804

10. Plate, Pennsylvania, 1820-40. Red earthenware, white slip, splashes of brown and green, sgraffito decoration, clear lead glaze; Diam. 30.2 cm. 60.695

11. Drawing with two rampant spotted unicorns, eastern Pennsylvania, 1795-1830. Watercolor and ink Fraktur on paper; H. 31.8 cm, W. 39.7 cm, by sight. See Fig. 58. 61.1113

12. *The Peaceable Kingdom,* Edward Hicks. Pennsylvania, ca. 1830. Oil on canvas; H. 44.8 cm, W. 59.8 cm. One of more than sixty versions painted by Hicks. The right side was inspired by Isaiah 11:6. To the left of the Quaker divines is his cousin Elias Hicks, who led the Hicksites, a group that broke with the Society of Friends in 1827 after their attempts at reform failed. 61.501

THE CONTRAST OF STYLES

HIGH STYLE

13. Desk and bookcase, Philadelphia, 1770-1800. Mahogany, cherry, pine; H. 254.6 cm, W. 114.3 cm. The restrained elegance frequently present in Philadelphia Chippendale furniture highlighted by the dentiled cornice, carved blind frieze, broken arch pediment with carved leaf volutes and pierced fretwork. 56.103.2

14. Side chair, probably Boston, 1770-80. Mahogany; H. 98.4 cm, W. 55.9 cm. The precisely proportioned simply carved crest rail, pierced splat, and marlboro legs make this another example of the fine American Chippendale craftsmanship available in the late eighteenth century. 55.166.3

15. Rug, central Anatolia, Turkey, 1875-1900. Wool, cotton; L. 213.4 cm, W. 144.8 cm. Probably a copy of an Ushak prayer rug, ca. 1700. 54.62.1

16. Tankard, Philip Syng, Jr. Philadelphia, 1745-65. Silver; H. 20.3 cm, W. 17.9 cm. A bellied tankard with a double C handle inscribed "S / IR." 61.620

17. Portrait of Benjamin Tevis, Thomas Sully. Philadelphia, 1822. Oil on canvas; H. 76.2 cm, W. 63.5 cm. Dated. The "TS" monogram appears on the lower left. The windswept hair and faraway gaze emulate English high style portraiture. 75.115

18. Tall clock with eight-day movement, probably Lancaster, Pennsylvania, 1800-1815. Mahogany, pine, mahogany veneers, inlays of zebra and satin woods; H. 271.8 cm. W. at hood 52.5 cm. The broken-arch pediment and colonnetted hood give way to a narrow waist with chamfered front corners and an eagle within an oval inlay. The base has chamfered front corners and a large inlaid shell. Movement attributed to George (Jr.) or John Hoff, 1805-1815. Quarter-hour chiming, hour-striking movement, with musical attachment for seven tunes. 57.1026

19. Occasional table with twelve-sided tilt top, New York City, ca. 1810. Carved mahogany; H. 71 cm, W. 60.5 cm. The proportions of the table and the skillful carving of the urn turned shaft and legs make this one of the best of its kind. 57.728

MOCK HIGH STYLE

20. Desk and bookcase, Pennsylvania, 1780-1810. White pine, painted; H. 254.3 cm, W. 104.5 cm. Energetic carving from the urn finial to the ogee bracket feet, is supplemented by applied decoration, punch work, and paint (brown, reddish brown, dark green, and white). See Fig. 75. 57.502

21. Side chair, shop of Major John Dunlap. New Hampshire, 1770-90. Carved and painted soft maple; H. 114 cm. W. 55 cm. "Banister Back't" chairs were sold by Samuel Dunlap for £4 each in 1790. See Fig. 72. 60.1054

22. Hooked rug based on a design by Edward Sands Frost, probably New England, 1870-1920. Wool surface, burlap backing; L. 175.9 cm, W. 91 cm. The medallion pattern is reminiscent of an oriental one. The design was copied by E. Ross & Company, Toledo, who listed it as no. 170 in their 1889 catalogue. 69.1950

23. Mug, attributed to William Will. Philadelphia, 1764-76. Pewter; H. 14.6 cm. Presented to Peter Ickes. "PHILAD" is stamped in a rectangle on the inside bottom, but this bears no maker's mark. It was cast in the same mold as a marked Will mug. See Fig. 102. 67.1369

24. Portrait of Oliver Crosby, Brookfield, Massachusetts, ca. 1790. Pastel on linen-backed paper; H. 60.8 cm, W. 45.7 cm. Crosby was seated in a fashionably high style pose (three-quarter view and looking off in the distance), but the apparently untutored artist had difficulty transferring an accurate and complimentary image to the paper. 57.1132

25. Tall clock with eight-day rack and snail mechanism, John Paul, Jr. Lykens Township, Dauphin County, Pennsylvania, 1815. Curly maple case, walnut and other wood inlays and appliqués, ivory keyhole escutcheon; H. 248.9 cm, W. 52.7 cm. Signed and dated. Fashionable style sources, traditional motifs, and exceptional but overzealous joinery combine in the clockcase to produce a unique statement of the cabinetmaker's art. See Pl. VIII and Fig. 98. 58.2874

26. Candlestand, probably northern New England, 1810-30. Birch, painted

mustard yellow, ornamented in brown; H. 65 cm, W., top, 36 cm x 37 cm. See Fig. 79. 57.1101

FOLK STYLE

27. Desk, Mahantango Valley, Pennsylvania, 1834. Tulip, painted; H. 124.8 cm, W. 99.1 cm. "JACOB / 1834 / MASER" painted in three panels below the fall-front lid. The ornamental designs were drawn from printed *Taufschein*. See Fig. 77. 64.1518

28. *Brettstuhl* ("plank chair"), probably Pennsylvania, 1770. Walnut, painted; H. 84 cm, W. 41 cm. Inscribed "IHA / 1770." This type of plank chair has been associated with Moravians in Pennsylvania and derives from the peasant chairs of southern Germany, Alsace, and Switzerland. See Fig. 71. 63.827

29. Shirred rug, probably New England, 1875-1925. Wool, cotton backing; L. 175.2 cm, W. 90.8 cm. The vase and long stemmed red flowers were arranged and stitched before the striated brown, tan, and red shirred background strips were added. See Fig. 7. 69.1949

30. Mug, America, 1830-70. Tinned sheet iron, iron wire, paint, asphaltum; H. 15.6 cm, W. 14.3 cm. Painted with a colorful but unusual sunburst. 65.1520

31. Unidentified man, attributed to Jacob Maentel. Probably Reading, Pennsylvania, 1825-35. Watercolor on wove rag paper; H. 31.5 cm, W. 20 cm. See Pl. VI. 57.1112

32. Watchstand, America, 1800-1850. Tulip, painted. H. 37.5 cm, W., of base, 33.6 cm. See Pl. I. 67.827

33. Tilt top table, possibly Pennsylvania, 1788. Black walnut; H. 69 cm, W., top, 61 cm x 60 cm. "DB 1788" inlaid in the three-board top. The hardware is heavy iron; the base resembles a piano stool to which legs have been bolted. 67.1178

WHO ARE THE FOLK

CHILDREN

34. Chamber table, Bath, Maine, 1816. Maple, birch, pine, painted decoration, traces of gilding on legs; H. 84 cm, W. 81.5 cm. "Rachel H. Lombard / Bath, January 1816" painted on drawer. Probably executed while she attended Bath Female Academy. See Figs. 21-23. 57.985

35. Work table with octagonal top, northern New England, 1800-1820. Maple frame, white pine, predominantly green painted decoration, silk bag; H. 74.5 cm, W. 39.5 cm. An example of school girl art that has a still life composition for its central motif. See Fig. 24. 57.892

36. *View in Nazareth Hall Garden,* Nazareth, Pennsylvania, 1796-1844. Watercolor and ink on wove paper; H. 19.4 cm, W. 24.2 cm. Probably produced by a student in a drawing class at the school, this is unusual because most school girls copied prints instead of attempting freehand compositions. 54.55.2

37. Needlework pastoral scene, Massachusetts, probably Boston, 1745-65. Wool and silk yarns on linen; primarily Roumanian couching, whip, and flat stitches; coarsely wrought; H. 22.9 cm, W. 38.1 cm, by sight. 58.2231

38. Needlework picture of Joab slaying Absalom, in original frame, Boston-Salem area, Massachusetts, 1760-80. Silk fabrics, silk yarns, human hair (on Absalom), paint (on faces); French knots, whip, and satin stitches; H. 51.4 cm, W. 55.9 cm. See Fig. 108. 59.1884

39. Sampler, Abigail Purintum. Probably Reading, Massachusetts, 1788. Silk yarns on linen; cross, satin, back, whip, eyelet, and bullion stitches; H. 40.6 cm, W. 40 cm. In addition to the alphabet and the numbers one through nine, the sampler contains a five-line poem, floral decoration, her name and age, and the date. 63.515

WOMEN

40. Bed rug with a lunette design, probably the Norwich-New London area, Connecticut, 1783. Wool, running stitches pulled flat; L. 228.6 cm, W. 221 cm. "W / RB / 1783" is worked in the top panel. See Fig. 13. 66.604

41. Needlework panel, attributed to Mary Dodge Burnham. Probably Boston or Newburyport, Massachusetts, 1725-60. Silk yarns on linen; French knots, Roumanian couching, whip, seed, and satin stitches; H. 41.3 cm, W. 157.2. cm. The absence of shaping along the lower edges of the lively garden scene indicates this may have been intended as a petticoat border. 62.12

42. Hooked rug with sheep and lambs, probably New England, 1870-1925. Cotton on burlap; L. 119.4 cm, W. 57.8 cm. 64.1355

43. Hooked rug, probably New England, 1870-1925. Cotton and wool on burlap; L. 228 cm, W. 62.9 cm. The runner has seven rows of houses. See Fig. 16. 64.804

44. Appliquéd picture, attributed to Sarah Furman Warner. Probably New York City, 1805-10. Linen, silk embroidery, cotton appliqués; 85.1 cm sq. The inn in this nativity scene was drawn as a Georgian house. The square probably was intended as the center of a quilt. 59.1946

45. Hand towel, Catarina Walborn. Probably Berks or eastern Lebanon County, Pennsylvania, dated 1827. Embroidered linen; cotton drawn work; fringed; L. 168.8 cm, W. 36.8 cm. Name stitched in red cross stitch. Embroidered decoration has twenty-one small motifs. 69.1145

46. Hooked rug with floral medallion, probably New England, 1830-60. Wool, linen; L. 185.4 cm, W. 81.3 cm. Hooked with heavy wool yarns similar to those used on bed rugs. 69.660

47. Needlework mourning picture, Margaret Bleecker Ten Eyck. Albany, New York, 1805. Silk fabric, silk yarns, hair; H. 56.5 cm, W. 29.34 cm. Inscribed "M. Ten. Eyck 1805" on the glass. The technique is called print work. See Fig. 25. 58.2877

48. Velvet painting of a mourning scene, probably New York State, 1810-20. H. 46.4 cm, W. 52.7 cm. This technique is often mistakenly called "theorem painting." See Fig. 26. 76.218

MEN

49. Firebucket, America, 1790-1820. Hand-sewn leather; H. 31.7 cm, Diam. 19.4 cm. Painted vignette depicts a fine wagon equipped with gilt nozzled hoses upon which are seated uniformed firemen. "R. V. Clarke" is painted in the panel below the vignette. 66.1044

50. Snipe with long bill pointing down, eastern United States, 1850-1900. White pine, painted; L. 30.5 cm, W. 5.1 cm. Brown, flat body, white markings on wings, tail feathers crossed. See Fig. 50. 65.1988

51. Snipe with long bill raised, eastern United States, 1850-1900. White pine, painted; L. 35.9 cm, W. 4.8 cm. Brown, flat sides, white markings on wings, tail feathers crossed. See Fig. 50. 65.1989

52. Priming flask, America, 1825-1900. Flattened Holstein horn, brass, wood; H. 14.9 cm, W. 9.5 cm. The engraved hunting scene on the front and the eagle motif on the back are crude enough to have been done by an amateur. Designed to be carried in a pocket. See Fig. 37. 67.863

53. Powderhorn, probably Pennsylvania, 1830-75. Flattened horn, wood, brass; L. 21.6 cm, W. 4.1 cm. Incised stylized flowers and a fantastic long-necked bird decorate two wide panels. The horn shades from ivory at the wide end to dark brown at the point. 67.1261

54. Powderhorn with leather strap, possibly America. Holstein horn, wood, leather, iron; L. 26.6 cm, Diam. 6.8 cm. "JOHN A. BUTTON / MARCH 1776" is inscribed on one side, but not until the nineteenth century were Holstein dairy cattle imported in large numbers which may mean this was a commemorative piece. The crude engraving includes birds, figures, and animals. 65.2744

55. Cutwork love letter, Lancaster, Pennsylvania, 1779. Watercolor and ink Fraktur; H. 31.4 cm, W. 31.1 cm, by sight. "Adam / Dambach, / In / Lancaster / 1779" hand printed in the central rosette. The hearts contain handwritten love messages, and the flowers are hand decorated. See Fig. 109. 65.1339

56. Cutwork valentine, possibly Chester or Delaware County, Pennsylvania, 1800-1810. Watercolor and ink on paper; H. 42.3 cm, W. 33 cm, by sight. Scalloped bordered circular cutwork decorated with flowers, birds, and hearts, superimposed on a rectangular sheet. "Dinah McFadgen" written in large script below the cutwork. The design is typical of Pennsylvania-German art. 67.895

TINSMITHS

57. Basket, decorated by Anna Maria Osmond, Chester County, Pennsylvania, or Kent County, Delaware, 1860-80. Tinned sheet iron, iron wire, paint; L. 17.1 cm, W. 10.1 cm. "Maria Osmond" is painted inside the bottom. The painting of tinned sheet iron objects in mid and late nineteenth century was often done by women, usually in the context of shop work, but occasionally as genteel work at home. See Fig. 12. 59.2301

58. Teapot, probably Pennsylvania, 1840-60. Tinned sheet iron, iron wire, paint, asphaltum; H. 21.9 cm, W. 21.9 cm. The colorful profusion of flowers climbing the sides of the pot represents the acme of popularly produced tinware in Pennsylvania. See Pl. II. 65.1673

59. Box with punched decoration, probably Pennsylvania, 1852. Tinned sheet iron, iron wire; H. (including handle) 27.9 cm, W. 34.6 cm. "J.E.CROSS 1852" punched into the front. Rosettes, hearts, and willows punch-decorated into the top and front. See Fig. 89. 65.1437

60. Engraved coffeepot, Pennsylvania, 1820-60. Tinned sheet iron, iron wire; H. 25.4 cm, W. 27 cm. Engraved

decoration of tinned sheet iron objects is rare; this example depicts an eagle with a snake and the American flag in its beak. 60.711

61. Coffeepot, Willoughby Shade. Philadelphia, ca. 1865. Tinned sheet iron, iron wire, brass; H. 28.2 cm, W. 26.5 cm. "W. SHADE" stamped on handle and "CATHARENAH MOYER" punched into base rim. See Fig. 17. 65.2152

62. Tray, attributed to Frederick and Louis Zeitz, Philadelphia, 1874. Tinned sheet iron, wire, paint, asphaltum; L. 31.4 cm, W. 22.3 cm. Marked on the bottom "1874 FZ / LZ." 65.1717

SEAFARERS

63. Sailor's bag, attributed to Warren Opie. Burlington, New Jersey, or shipboard, 1850-65. Linen bag, wool seams, cotton appliqués, silk embroidered chain stitch; H. 85.1 cm, Diam. 40.6 cm. His name, the names of his parents and sisters, "BURLINGTON NEW JERSEY," and "GOD AND OUR COUNTRY" are stitched on the bag. 67.932

64. Needlework picture, America, 1877. Cotton sail canvas, merino yarn, newspaper sewn to the back; H. 60 cm, W. 80 cm. Pictures with ships at sea are usually English. This one is strikingly similar to English examples; however, the flags on the ships are American, and the newspaper (backing) was printed in Boston in 1877. 59.2983

65. Scrimshaw, America, 1825-50. Whale tooth; H. 8.8 cm, L. 22.5 cm. A good example of a simple chase scene and a whale with his "chimney afire." The men's hats and the type of harpoon date this in the first half of the nineteenth century. 67.861

Plate VIII. *Detail of the front panel
of the John Paul, Jr., tall clock.
Nationalistic fervor, state loyalty, and
ethnic allegiance are conveyed by the
inlays which include the coat of arms
of the Commonwealth of Pennsylvania.*

Plate VIII. *Tall clock with eight-day
rack and snail striking mechanism,
John Paul, Jr. Lykens Township,
Dauphin County, Pennsylvania, dated
1815. Curly maple case, wood inlays
and appliqués; H. 248.9 cm.
Structurally the case is an example of
over-engineered joinery.* 58.2874

66. Scrimshaw, America, 1825-60. Whale tooth; H. 21 cm, W. 8.9 cm. See Fig. 107. 67.862

67. Scrimshaw plaque, America, 1825-65. Sperm whale panbone; H. 19.5 cm, W. 36.2 cm. The large whalers are rigged as barks, not ships, which date this piece in the mid-century. See Fig. 30. 67.890

68. Scrimshaw, America, 1790-1830. Whale tooth, H. 17.1 cm, W. 6.3 cm. Decorated with a house on one side and a rose in a vase above a three-masted ship on the other. The decoration is atypical, and the oriental-looking flower and base suggest the carver served on a ship that participated in the China trade. 67.875

69. Dipper, New England, 1825-60. Coconut shell, wood handle; H. 12 cm. Inscribed on the handle "OA." Incised pinwheel and a sawtooth band on the shell. The handle pierces the diameter of the shell. 65.1837

70. Scrimshaw jagging or pastry wheel, America, 1825-1900. Whale tooth carving in the shape of a sperm whale; H. 12.4 cm, W. 8 cm. The three tined fork, attached below the tail, provides balance. 67.870

POTTERS

71. Plate, Jacob Joder. Probably Berks County, Pennsylvania, 1800. Thrown red earthenware, white slip, splashes of green, sgraffito decoration, clear lead glaze; Diam. 30.9 cm. Back incised "Jacob Joder / 1800." Front incised "Aus der ert mit ver stant macht der häffner aller hand::. glück glahs und erd ist sein gelt ehrlich wert." See Fig. 86. 60.688

72. Dish, Conrad R. Ranninger. Montgomery County, Pennsylvania, 1838. Red earthenware, white slip around leaves, splashes of green, clear lead glaze; Diam. 24.4 cm. Back incised "June th23 1838 / Conrad R. Ranninger / Montgomery County." Partial date on front. The use of leaves is distinctive. See Fig. 87. 67.1612

73. Dish, possibly by John Strawn. Probably Bucks County, Pennsylvania, 1797. Thrown red earthenware, white slip, splashes of green, sgraffito decoration, clear lead glaze; Diam. 36.5 cm. Incised "Py and Cream was thare Sceem this Thing it Past amongs the youth thay Can not Deny & Speak the truth / This thing it Caused them to Comply Witch they Cannot Deny you have it as Cheep as I March 10th 1797 John Strawn." Quaker potters named Strawn are known to have worked in Bucks County and stylistically the dish is related to those there. See Fig. 93. 65.2302

74. Dish, probably Pennsylvania, 1820-60. Red earthenware, white slip-trailed decoration, clear lead glaze; Diam. 17 cm. The pipe-smoker is an unusual theme in American slipware. See Fig. 111. 59.2252

75. Jars, Solomon Bell pottery. Strasburg, Virginia, 1870-80. Red earthenware, white slip, highlighted with gray slip and yellow-green lead glaze; H. 40.6 cm, W. 40 cm. Stamped "SOLOMON BELL / STRASBURG" and probably made by Bell's nephew, Richard Franklin Bell. The applied eagles hold banners labeled C—— Gilbert [?] & Company which indicates the eagle mold was either made for or by another commercial firm. The use of yellow-green glaze highlights on flat

white slip is peculiar to Shenandoah Valley potteries. See Fig. 27. 67.1623.1, .2

76. Jar, possibly by Philip Lükolz. Pennsylvania, 1788. Red earthenware, white slip, splashes of green, sgraffito decoration, clear lead glaze; H. 20.6 cm, Diam. 13.3 cm. Incised around neck "philib lükholz den 5 ocdomer 1788." Sgraffito decoration is customarily used on plates and dishes and only rarely on jars or other forms. 65.2706

77. Dish, America, 1810-40. Red earthenware, colored slips to produce surface "marbling," clear lead glaze; L. 34.6 cm, W. 26.4 cm. The early American potter probably was influenced by British imports of marbled or agate effects, although the technique is old and has been widely practiced. See Fig. 92. 65.2316

78. Octagonal dish, probably Pennsylvania, 1794. Red earthenware, relief molded, clear lead glaze; H. 42 cm. W. 20.9 cm. Relief-molded inscription in center "17 IT 94." The method of decoration is unusual. The clay was pressed over a mold whose convex surface was deeply incised with the date, initials, central tulip motif, and, on the periphery, other flowers. "IT" may be Jacob Taney. 65.2306

79. Dish, Pennsylvania, 1820-50. Red earthenware, white slip-trailed decoration, splashes of green, clear lead glaze; Diam. 40.4 cm, H. 6.9 cm. See Fig. 91. 67.1506

80. Vase on pedestal base, Anthony W. Baecher. Winchester, Virginia, 1868-89. Red earthenware, white slip, relief decoration, green glaze; H. 24.6 cm, W. 20.3 cm. "BAECHER / WINCHESTER VA"'

stamped on bowl and stand. The high relief birds and flowers are typical of Baecher's work and characteristic of Shenandoah Valley potteries of the period. See Fig. 48. 67.1679

81. Jug, possibly Connecticut, 1810-40. Gray stoneware, cobalt-filled incised design, salt glaze. The labeled buildings in an unusual landscape scene include a wood house, coach house, glass house, stock house, smoke house, and the main house. The ship is labeled "Gleaner." See Figs. 104, 105. 57.549

82. Bowl attributed to Caln Pottery of Thomas Vickers and Son. Near Downingtown, Pennsylvania, 1806. Red earthenware, white slip, sgraffito decoration, green glaze; H. 11.4 cm, Diam. 24.3 cm. "Rachael Heston" and "1806" incised on opposite sides. A similar bowl signed by Vickers is in the North Museum, Franklin and Marshall College, Lancaster, Pennsylvania. See Fig. 96. 67.1593

83. Mermaid flower holder (wall pocket), possibly Pennsylvania, ca. 1850. Red earthenware, incised detail, white slip, splashes of green, clear lead glaze; H. 22.2 cm, W. 12 cm. The mate is in the Brooklyn Museum. Mermaids have been associated with the new world since Columbus sighted one in 1493, and their forms frequently decorated early maps and Pennsylvania-German Fraktur. See Fig. 19. 58.120.26

BLACKSMITHS

84. Trivet, attributed to James Sellers. Philadelphia, 1837. Wrought iron; L. 30.3 cm, W. 12.4 cm. Stamped, "J. Sellers," incised "BM / 1837." See Fig. 1. 60.788

85. Rooster weathervane, America, 1800-1900. Sheet iron, wrought iron, originally gilded; H. 69.8 cm, W. 58.4 cm. See Fig. 18. 57.112

86. Flesh fork, attributed to Peter Eisenhauer. Hereford Township, Berks County, Pennsylvania, 1776. Steel incised decoration, inlaid brass inscription; L. 38.2 cm, W. 4.5 cm. Inscription: front, "M:EISENHAUER"; back, "1776." See Fig. 90. 60.792

87. Commission banner, America, 1800-1900. Galvanized sheet iron, copper and iron rivets, paint; L. 88.3 cm, W. 43.2 cm. Commission pennants are flown from the mainmast of government ships under the command of officers who are not entitled to personal flags, but this metal pennant with thirteen stars and seven stripes was probably an adaptation for commercial use in a parade. 59.2370

88. Locksmith's shop sign, America, 1750-1850. Sheet iron, wrought iron, originally gilded; H. 58.2 cm, W. 31.1 cm. Gilding made such signs more visible, and it retarded the rusting process. See Fig. 20. 59.1801

89. "Suffolk latch" door handle. Vergennes, Vermont, 1820. Wrought iron, incised and stamped decoration. Punch decoration includes "1820," the Freemasons' square and compass, and the all-seeing eye. H. 47.6 cm. See Fig. 2. 52.11

90. Hinge, probably Pennsylvania, 1800. Wrought iron; L. 97.8 cm, W. 12.4 cm. Initials "SW" worked in left side and "1800" worked in right side. See Fig. 14. 69.1953

ARTISTS

91. Portrait of Adam Winne, Hudson River Valley, possibly Albany, New York, 1730. H. 81.3 cm, W. 67.3 cm. "ADAM WINNE / AE. 1730" in lower right corner. Possibly painted by the Gansevoort Limner (Pieter Vanderlyn?). The composition of the portrait indicates influence of English mezzotints. 58.1146

92. Eagle, attributed to Wilhelm Schimmel. Cumberland County, Pennsylvania, 1865-90. Unpainted butternut; H. 19 cm, W. 27.3 cm. Rough carving marks are visible, especially on the wings and tail. 59.2346

93. Eagle, attributed to Wilhelm Schimmel. Cumberland County, Pennsylvania, 1865-90. White pine, painted; H. 60.3 cm, W. 92.5 cm. See Fig. 9. 59.2341

94. *Zierschrift* ("decorative writing"), signed Jacob Strickler. Massanutten settlement (near Luray), Shenandoah (now Page) County, Virginia, dated February 16, 1794. Watercolor and ink Fraktur on laid rag paper; H. 31 cm, W. 36.8 cm. Of Swiss descent, Strickler was probably a Mennonite preacher or a school teacher. See Fig. 57. 57.1208

95. Drawing of a boy with rooster, attributed to Jacob Maentel. York, Lebanon, or Lancaster County, Pennsylvania, 1815-25. Watercolor on paper. H. 20 cm, W. 14.6 cm. Inscription on back: "Blauen Reid mit Weisse Knopfe / Do Pantalons / Weiss roth and gelb / Streifen Schwartze Wüste" indicates the profile was drawn on the spot but the color was not added until later. See Fig. 59. 57.1119

96. Sign, B. Little. Probably Hudson River Valley. Oil on white pine; H. 148.3 cm, W. 241.9 cm. A female in classical garb holding an oversized cornucopia sits in a coach drawn by a pair of small lionesses. Inscribed: in the banner above, "PLENTY and PEACE throughout the WORLD" and in the legend below "B. LITTLE, COACH PAINTER." 59.2439

97. Overmantel hunting scene, probably Massachusetts, ca. 1800. Oil on white pine; H. 68.9 cm, W. 171 cm. The stag hunt scene may have been inspired by an English print, wallpaper, or needlework. See Fig. 81. 64.2101

98. Fireboard, possibly Sutton, Massachusetts, 1830-50. Oil on white pine; H. 67.3 cm. One of five related fireboards depicting a fireplace surrounded by tiles. In each the fireplace is painted in perspective, and three depict central vase with flowers. See Fig. 85. 67.1859

99. *Haus-Segen* ("house blessing"), eastern Pennsylvania, dated 1803. Watercolor and ink Fraktur; H. 31.7 cm, W. 39 cm, by sight. This rare Fraktur is a hand done Mennonite-type drawing. The griffin (evil) is trapped within the circle and unable to fly away thereby robbing the world of its pearls (souls). See Pl. IV. 57.1190

100. *Taufwunsch* ("baptismal wish") for Stovel (Christopher) Ehmrich, attributed to the Sussel-Washington Artist. Bethel Township, Berks County, Pennsylvania, 1771-80. Watercolor and ink Fraktur on paper; H. 18.8 cm, W. 23.2 cm, by sight. The unconventional text lacks the usual phrasing. The drawing, one of several attributed to the artist, who specialized portraying women in German peasant garb, is his most elaborate composition. 58.120.15

101. Bookmark, eastern Pennsylvania, 1790-1820. Watercolor and ink Fraktur on wove rag paper; H. 17 cm, W. 10.2 cm. See Fig. 51. 57.1

102. *Sing-Bild* ("sing picture") of Maria Miller, attributed to Jacob Oberholtzer. Vincent Township, Chester County, Pennsylvania, dated February 7, 1789. Watercolor and ink Fraktur on laid rag paper; H. 20 cm, W. 17 cm, by sight. 57.1248

103. *Taufschein* ("birth and baptismal certificate") of Johannes Kreniger, eastern Pennsylvania, ca. 1798. Watercolor and ink Fraktur on laid rag paper. H. 32.7 cm, W. 39 cm. See Fig. 33. 61.1109

104. *Geistlicher Irregarten* ("spiritual garden-maze"), attributed to Heinrich Otto. Cocalico Township, Lancaster, County, Pennsylvania, 1784. Press printed; watercolor and ink on paper; H. 53 cm, W. 41.9 cm. The borders are hand drawn. Otto introduced and popularized press printed Fraktur. This is the first of three Irregarten forms he printed on the press at nearby Ephrata between 1784 and 1788. The maze itself was common in European art and in written German religious texts. Otto also introduced this parrot decoration which was widely imitated. 58.120.13

105. *Taufschein* of Cornelius Dotter, Chestnut Hill Township, Northampton County, Pennsylvania, ca. 1826. Watercolor and ink Fraktur; H. 39.4 cm, W. 31.2 cm. See Fig. 10. 61.1105

106. Fringed hand towel, probably Pennsylvania, 1800-1870. Linen with cross stitch embroidery; L. 123.2, W. 33.1 cm. Initials "M" and "K" worked in the top corners. See Fig. 15. 69.1164

107. Tape loom, decorated by John Drissel. Upper Bucks County, Pennsylvania, 1795. White pine, painted; H. 44.5 cm, W. 24.8 cm. Inscription on faceboard: "Anna Stauffer AO 1795 / Den 2 fem Mai, john Drisel his hand and pen." See Fig. 84. 59.2812

108. Covered cup, possibly Pennsylvania, 1820-50. Maple, painted decoration; H. 18.1 cm, Diam. 9.2 cm. Possibly an apprentice piece made in the style of Joseph Lehn. See Fig. 80. 67.1830

109. Blanket chest, Lebanon County, Pennsylvania, 1765-1800. Pine, painted; H. 62.8 cm, W. 127 cm. The hearts, birds, flowerettes, tulips, vines, and Adam and Eve in the Garden of Eden are common eighteenth- and early nineteenth-century decorations. See Fig. 62. 57.99.4

110. *Schrank* ("clothes press") Lancaster County, Pennsylvania, 1768. Walnut, *Wachseinlegen* ("wax inlay") technique; H. 227.3 cm, W. 217.8 cm. Inlaid in the upper left cartouche "EMANUEL · HERR / FEB · D · 17," and in the upper right cartouche "MA · HER / 1768." This and three similar schranks possibly by the same hand derive from Rhine Valley construction techniques. See Fig. 73. 65.2262

111. Washbasin, Pennsylvania, 1850-1900. Red earthenware, stamped and modeled decoration, brown glaze; H. 21.7 cm, W. 38.4 cm. Small semicircular soap pocket near the rim, center back. Strap handle at each side. 67.746

112. Plate, attributed to David Spinner. Milford Township, Bucks County, Pennsylvania 1800-1810. Red earthenware, white slip, splashes of green, sgraffito decoration, clear lead glaze;

Diam. 30.5 cm. Incised above the two figures is "Hansel und / Kretel." Although German and Swiss potters commonly depicted humans, few Pennsylvania potters besides Spinner did so. Two similar plates signed by Spinner are in the Brooklyn Museum. See Fig. 86. 60.652

113. Plate, attributed to Rudolf Drach. Bucks or Northampton County, Pennsylvania, 1798. Red earthenware, white slip, splashes of green, sgraffito decoration, lead glaze; Diam. 29.2 cm. Incised in rows on front: "Liewer wilt ich l[e]dig leben als / der frau die hosen geben 1798 / lieb mich allein oder laes gar sein / borgen machd sorgen meich / drach" (Rather would I single live than to my wife the britches give, 1798, love only me or let me be, keeping things hidden brings trouble. drach). Drach typically inscribed in rows rather than around the rim. 67.1609

114. Plate, attributed to Samuel Troxel. Upper Hanover Township, Montgomery County, Pennsylvania, 1830. Red earthenware, white slip, splashes of green, sgraffito decoration, clear lead glaze; Diam. 28.6 cm. Incised around rim: "A ist ein amtmann verständig und klug; B ist ein bauer und liebet den pflug; C ist ein captain und schützet / das land; D ist ein dumkopf und hasset verstand; 1830" (A stands for magistrate sensible and wise; B stands for farmer at home with the plough; C stands for captain who protects the land; D stands for block head who can't stand learning). The plate is similar to other documented Troxel pieces. 60.659

115. Plate, attributed to George Hübener. Montgomery County, Pennsylvania, 1787. Thrown red earthenware, white slip, splashes of green,

sgraffito decoration, clear lead glaze; Diam. 34.8 cm. Incised around rim: "Wann das mænngen, und das hengen nicht wehr, so stænden die wiegen und hickel heusser Lehr:, September, 14tm. 1787" (Were there no men or roosters left, empty would be cradles and also chicken pens). Hübener signed or initialed other plates decorated with similar peacocks and tulips. 65.2300

116. Inkstand with pelican and her young, America, 1861. Red earthenware, pierced and modeled decoration, stamped detail, brown glaze; H. 17.8 cm, W. 22.2 cm. Incised on bottom "John E-ustus / Beuher King S——— / 1861." This is an unusually ambitious and successful example of American pottery. 60.624

USES OF FOLK OBJECTS

LIGHTING

117. Wall sconce, America, ca. 1871. Tinned sheet iron, iron wire, paint; H. 32.1 cm, W. 11.8 cm. Inscription in pencil on back: "I / 1871 / 1871." The rolled wire edges indicate this was made in a tinsmith's shop rather than at home. The mustard ground with green sponged splotches is an unusual painted decoration and probably was added by the purchaser, who also added the pencil inscription. See Fig. 66. 59.2101

118. Wall sconce, probably New England, 1830-60. Tinned sheet iron, iron wire punched decoration, machine crimped edges; H. 34 cm, W. 9.7 cm. The heart-shaped faces at the top and bottom may be a derivative of seventeenth-century funerary art. See Fig. 66. 60.708

119. Wall sconce, probably New England, 1825-75. Tinned sheet iron, punched

decoration; H. 51.1 cm, W. 8.9 cm. One of the six identical sconces with a leaf decoration, See Fig. 66. 67.1549.2

120. Tripod candlestand, probably New York State, 1720-80. Wrought iron; H. 169.9 cm, W. 48.9 cm. In America double-armed wrought iron candlestands are uncommon. This example is particularly unusual because of the silhouetted human finial and the use of iron instead of brass for the candle cups and bôbeches. These features probably indicate rural manufacture. 58.1047

121. Figure with a candleholder (one of a pair), Solomon Bell pottery. Strasburg, Virginia, 1888-89. Red earthenware, white slip, stamped decoration, mottled lead glaze; H. 40 cm, W. 16.2 cm. Impressed "s. BELL & SON / STRASBURG" and made by Richard Franklin Bell as a wedding gift for Mrs. D. H. Benchoff in 1889. See Fig. 8. 67.1626

122. Figure with a candleholder (one of a pair), Solomon Bell pottery. Strasburg, Virginia, 1860-90. Red earthenware, white slip, mottled lead glaze; H. 39.4 cm, W. 16.2 cm. The attribution is based upon signed Bell candleholders. See Fig. 8. 67.1627

123. Chandelier, America, 1750-1850. Tinned sheet iron, wood, iron wire, gesso, paint; H. 71 cm, W. 100.3 cm. Twenty-four candles on two tiers of branches. 59.1493

STORAGE

124. Chest with drawers, Taunton area, 1742. White pine, chestnut, red oak; painted decoration; H. 70.8 cm, W. 61 cm. Date painted on the first drawer. These designs are related to others produced in the Taunton area. See Fig. 69. 54.510

125. Blanket chest with two drawers, Lancaster, Pennsylvania, 1741. Walnut, tulip, and poplar, inlaid decoration; H. 74.3 cm, L. 122.5 cm. Inscribed on front panel "ITI / 1741." The chest is the earliest dated chest with a history of being made in Pennsylvania. Probably it was made by an English-American craftsman, possibly for Isaac Taylor of Lancaster County, near Gap. 57.1108

126. Chest with four drawers, Saybrook-Guilford area, Connecticut, 1724. Tulip, white pine moldings, painted decoration; H. 113 cm, W. 108 cm. Inscribed on the upper section "in ye / 1724" and "SH" 58.1501

127. *Spanschachteln* ("chip box"); America, 1836. Arborvitae, painted; H. 19 cm, L. 41 cm. Lid has a painted tulip decoration and is inscribed on lower border "A.M.G. 1836." Quite common in Germany, chip boxes are made of single plywood strips bent around an oval base. This one is made of an American wood. 67.749

128. Box with lid, possibly America, 1800-1875. White pine; H. 15 cm, L. 38.5 cm. The box is nailed together. The painted decoration includes flowers, fruits, heraldic beasts, and birds. Pencil or crayon inscription inside lid: "CM Gra——." 65.2187

129. Miniature chest, Pennsylvania, 1785. Tulip, casein colors for decoration and inscription on base; H. 22.5 cm, L. 42 cm. Inscriptions: on front, "17/85," on base in red paint, "FE · BER · Y / · 1785 · / · CA · SL ·" Decorated with pinwheels, tulips, and a parrot similar to one drawn by Heinrich Otto. See Fig. 67. 59.2806

130. Dome-top box, Lancaster County, Pennsylvania, 1814. Tulip, painted decoration, punched tin escutcheon;

H. 20 cm. Penciled inscription on bottom: "February 12, 1814 / Lancaster / Jonas H——." Allover pattern of stylized flowers drawn with a compass. See Fig. 65. 65.1981

131. Miniature chest, Lancaster County, Pennsylvania, 1773. Walnut *Wachseinlegen* ("wax inlay") decoration; H. 19 cm, L. 37.5 cm. Inlaid on lid, "Iohannes / 17 / 73 / Mosser." See Fig. 68. 65.2256

132. Trinket or bureau box, mid-Atlantic region, possibly Pennsylvania, 1835-40. White cedar, painted; H. 7 cm, L. 29 cm. Inscription on lid: "E.L.I." Top decorated with red and white tulips and a church. Similar to boxes attributed to H. Bucher. 64.2058

133. Miniature chest with three drawers, possibly America, 1800-1850. Tulip, pine, painted; H. 19 cm, L. 25.9 cm. The chest is nailed and glued and may have been constructed from scraps of picture frame molding; the corners are mitred. Penciled inscriptions on the inside and bottoms of the drawers indicate mementoes may have been stored in the chest. See Fig. 70. 67.710

134. Box with sliding lid, America, probably Pennsylvania, 1800-1900. Pine, painted; H. 14 cm, L. 38 cm. Painted decorations include a heart and stylized carnations and tulips. 67.1276

135. Box, probably Lancaster County, Pennsylvania, 1845-50. White pine, painted; H. 14 cm, W. 26 cm. Painted inscription on front: "Isaac Wesner." Floral decoration on lid and ends, house flanked by trees on the front. 67.1285

REST AND REPOSE

136. Chair seat, Massachusetts, probably Boston, 1740-70. Wool, linen, silk, beads; Roumanian couching, whip, herringbone, and weaving stitches; H. 40 cm, W. 50.5 cm. Related in design to Boston scenic work. 58.2219

137. Chair seat, probably New England, 1730-80. Wool, linen; Roumanian couching, French knots, whip, and bullion stitches; 39.4 cm x 39.4 cm. A crude design including Venus, a chariot, a toga-draped man, a rowboat, six small cherubim, and a dove. 61.1190

138. Bed rug, Mary Foote. Colchester, Connecticut, 1778. Wool; taut floral design worked in various darning stitches, background covered with a diamond pattern darning stitch; L. 212.1 cm, W. 196.9 cm. "MARY FOOT AD 1778" worked in top edge. Her sister Elizabeth made an identical coverlet, now at the Connecticut Historical Society. 60.594

139. Embroidered blanket, America, 1800-1830. Wool; Roumanian couching and whip stitches, handmade fringe; L. 302.9 cm, W. 185.4 cm. See Fig. 31. 69.558

140. Windsor side chair, New England, 1795-1815. Aspen, soft maple, white oak, painted; H. 87.6 cm, W. 57.8 cm. The unusual scroll ears and bow are one piece. See Fig. 76. 64.1173

141. Bed rug, probably Connecticut River Valley, 1819. Wool, linen; loose running stitch; L. 247.4 cm, W. 236.2 cm. "NC / 1819" worked into a medallion at the top. The stylized floral design is worked in heavy yarns. 64.1641

142. Quilt, New England, 1800-1840. Wool, linen; appliquéd, pieced, and embroidered diamonds with floral motifs in alternating rows; L. 198 cm, W. 155 cm. 69.562

FOOD PREPARATION

143. Cakeboard, John Conger. New York City, 1827-35. Mahogany, intaglio carved design; L. 61 cm, W. 33.5 cm. Stamped "J. Y. Watkins [tinsmith and owner of a kitchen furnishing warehouse], N.Y." and "J. Conger" (carver and baker). 55.48.60

144. Spoon rack, Hudson River Valley or New Jersey, 1750-1800. Tulip, chip carved, painted; H. 53 cm, W. 22.5 cm. See Fig. 64. 59.2813

145. Toaster, America, 1750-1800. Wrought iron, ash; W. 31.1 cm, H. 14.2 cm, L., of handle, 65.4 cm. See Fig. 4 66.527

146. Trammel, possibly Pennsylvania, 1700-1800. Wrought iron, wrought and punched decoration; L. (max.) 172.1 cm, W. 19.4 cm. See Fig. 3. 65.2842

147. *Kiche Schrank* ("kitchen cupboard") Pennsylvania, 1800-1830. Pine, tulip, painted; H. 214 cm, W. 151 cm. See Pl. VII. 64.1897

148. Hanging cupboard, probably Pennsylvania, 1775-1825. White pine, painted; H. 108.5 cm, W. 57.7 cm. "P / EP" painted on the crest. See Fig. 56. 67.844

149. Salt box, upper Bucks County, Pennsylvania, 1797. White pine, painted; H. 28 cm, W. 18.5 cm. Decorated by John Drissel. Signed "ANNE LETERMAN / Anno Dommni 1797 / John Drissell / his hand May / th 22, 1797." See Fig. 83. 58.17.1

150. Mug, John Bell. Waynesboro, Pennsylvania, 1840-65. Buff earthenware, brown decoration, clear lead glaze; H. 10.8 cm, W. 13 cm. Stamped "JOHN BELL." Similar designs appeared on English mocha ware. See Fig. 97. 60.556

151. Woman-shaped bottle, America, 1825-75. Red earthenware, splashes of green and brown, clear lead glaze, cork attached to the removable head; H. 21.6 cm, Diam. 10 cm, at base. Possibly incised "I M" on bottom. See Fig. 19. 65.2008

152. Tea canister, possibly Wrightstown, Bucks County, Pennsylvania, 1769. Red earthenware, splashes of green and brown, white slip, sgraffito decoration, clear lead glaze; H. 21 cm, W. 14.2 cm. Inscribed "1769" and "L. Smith / T E A." See Fig. 103. 57.1390

153. Turtle-shaped pocket bottle, Pennsylvania or the South, 1797. Molded red earthenware, incised detail, clear lead glaze. Dated, possibly a "T" incised on the bottom. Similar bottles were made in Salem, North Carolina, about this time. See Fig. 19. 65.2309

154. Fish-shaped pocket bottle, Salem, North Carolina, 1810-30. Molded red earthenware, green glaze; L. 17.1 cm, W. 8.9 cm. The mold was designed by Rudolph Christ. See Fig. 19. 59.2147

155. Jug, possibly New York State, 1800. Buff stoneware, cobalt-filled incised decoration, salt glaze; H. 18.4 cm, W. 10.8 cm. The initials "J R" incised in one side may be those of the maker. See Fig. 106. 58.1098

156. Covered jar, Piedmont area, North Carolina, 1800-1830. Red earthenware, white slip-trailed decoration, splashes of green, clear lead glaze; H. 27.6 cm, W. 22.9 cm. See Fig. 88. 61.1134

157. Plate, Pennsylvania, 1800-1825. Red earthenware, white slip, incised and combed decoration, green coloring, clear lead glaze; Diam. 30.9 cm. Combed decoration is not normally seen in American slipware, and fish are not common designs on Pennsylvania pottery. See Fig. 46. 55.109.5

158. Jug, attributed to Frederick Carpenter. Charlestown, Massachusetts, 1804-13. Buff stoneware, cobalt-filled incised decoration, brown slip interior, salt glaze; H. 28.5 cm, W. 19.6 cm. Stamped "BOSTON." Carpenter apparently used the stamp for wares to be sold at the Boston shop of his benefactor, William Little. See Fig. 11. 55.61.8

159. Pot, John and Edward Norton pottery. Bennington, Vermont, 1850-59. Buff stoneware, cobolt decoration, brown slip interior, salt glaze; H. 22.9 cm, W. 27.6 cm. Stamped "J. & E. NORTON / BENNINGTON VT." and painted with a deer on a landscape. 62.10

160. Water cooler or keg, C. Goetz, Smith & Jones, Slago Pottery. Zanesville, Ohio, ca. 1850. Yellow earthenware, brown slip-trailed and relief-molded decoration, clear lead glaze; H. 40.4 cm. The names and location are incised on the sides. The cooler supposedly was made for the Eagle Hotel in Zanesville. The eagle motif was made from a mold taken from a pressed glass salt of a pattern attributed to the Boston and Sandwich Glass Company. See Fig. 94. 59.2188

161. Water cooler or keg, America, 1853. Gray stoneware, cobalt-filled incised designs, relief decoration, salt glaze; H. 66 cm. "T. Whitemann" incised in one side may be the owner or maker. See Fig. 95. 59.1926

162. Hanging cupboard with scrolled, broken-arch pediment, Pennsylvania, 1792. Walnut, ivory decoration, pine; H. 73.6 cm, W. 48 cm. Date incised on door. 67.1169

163. *Kiche Schrank* ("kitchen cupboard") with open upper section. Pennsylvania 1750-1800. White pine, painted; H. 213.4 cm, W. 163.2 cm. 67.1171

164. Hanging cupboard, Pennsylvania, 1750-1825. White pine, painted; H. 92.6 cm, W. 98.1 cm. 64.1591

RECORDS

165. Two scenes from "The Prodigal Son" (the son in misery and the son returning), attributed to Frederick Krebs. Eastern Pennsylvania, probably Dauphin (now Lebanon) County, 1800-1805. Watercolor and ink Fraktur; H. 38.1 cm, W. 30.2 cm. 54.54

166. *Adam U=* / *Eva*, Pennsylvania 1766. Oil on white pine; H. 62.2 cm, W. 39.1 cm. Dated "1766" at the bottom. Probably from a church. 59.1710

167. Drawing, possibly Pennsylvania, 1810-25. Watercolor and ink on wove rag paper; L. 31.8 cm, H. 6.3 cm. Inscribed: "We are going to Attend Sunday School, and Shun bad company, to day." See Fig. 101. 61.47

168. Drawing, probably Pennsylvania, 1810-20. Watercolor and ink Fraktur on wove rag paper; L. 22.5 cm, W. 12.7 cm. See Fig. 41. 61.1114

169. Drawing, eastern Pennsylvania, 1800-1820. Watercolor and ink Fraktur on laid rag paper; L. 40.7 cm, H. 33.3 cm. Possibly of Mennonite origin, this may depict a military wedding. See Fig. 100. 61.1124

170. GENERAL GEORGE WASHINGTON, Reviewing the Western Army at Fort Cumberland the 18th of October 1794, Frederick Kemmelmeyer. Maryland, post 1794. Oil on linen-backed paper; H. 46 cm, W. 58.8 cm. Signed "F. Kemmelmeyer Pinxit." The troops were called to subdue the rioting farmers of western Pennsylvania in the Whiskey Rebellion. See Fig. 38. 58.2780

171. WE HAVE MET THE ENEMY / AND THEY ARE OURS, America, post 1816. Oil on wood; H. 42.2 cm, W. 29.5 cm. A copy of a print drawn by J. R. Penniman, engraved by W. B. Annin for the frontispiece of *The Naval Monument* published by Abel Bowen in 1816. 59.1941

172. Napoleon Bonaparte, attributed to Henry Herr. Probably Pennsylvania, 1810. Watercolor and ink on laid paper; H. 23 cm, W. 12.7 cm. Inscribed "BONEPARTE KING / GENERAL WENE [Wayne?] 1810." 57.1149

173. Jug, possibly Connecticut or mid-Atlantic region, 1810-40. Gray stoneware, relief-molded bust of Jesus Christ, impressed decoration, salt glaze; H. 31.7 cm, Diam. 14 cm, at base. "G. WASHINGTON / FOR. EVER" impressed below the bust. See Fig. 74. 61.162

174. Plate, probably Pennsylvania, 1793. Red earthenware, yellow and green slip, clear lead glaze; Diam. 35 cm. Slip portraits above the names "Franklin. Jefferson. / 1793." A matching plate features Washington and Lafayette. 67.1671

175. Two houses, probably New England, ca. 1815. Watercolor and pencil on paper. H. 12.7 cm, W. 16.5 cm. 57.1150

176. Hooked rug, Canada or northern New England, 1860-1920. Wool, cotton, burlap, uncut pile. L. 149.2 cm, W. 78.7 cm. Below the main doorway of the house "s f" is worked into the fabric. 69.1948

177. A VIEW AT APPOQUINIMINK. STATE OF DELAWARE. July the 14th, 18——, attributed to George Washington Janvier. Probably Delaware, 1820-40. Watercolor and ink on wove rag paper; H. 11.9 cm, W. 15.9 cm. Appoquini-mink, now Odessa, was an important export center for grain between 1820 and 1840. 75.26

178. A PLAN OF NEW GLOUCESTER, Joshua H. Bussell. Alfred, Maine, 1850. Water-color and ink on paper; H. 52 cm, W. 96 cm. Inscribed "A / Plan of / New Gloucester. / State of Maine. / Delineated by / Joshua H. Bussell / Alfred, Me / January 1st / 1850" accompanied by a legend identifying the buildings. See Fig. 82. SA 1535

179. Birth record, probably Union Company, New Jersey, 1830. Watercolor and ink on paper; H. 16.5 cm, W. 20.8 cm. Inscribed "Jonathan Weller was Born march / 6th. 1809." and, in the margin below, "P.R. Saturday March 13th, 1830, Rainy day." 65.1338

180. Needlework mourning picture, Lucy Nye. Probably northern New England, 1810-20. Silk, paper, and ink on cotton; H. 28.6 cm, W. 27.6 cm. "Blossoms fruits / and flowers / together rise / and the whole / year in gay confusion lies," written on tomb. Signed "Lucy Nye born April 4th, 1799." See Fig. 110. 64.775

181. Hand towel, attributed to Martha Schyfer. Probably Pennsylvania, 1839. Linen, drawn work, cotton embroidery, fringe; L. 141.1 cm, W. 46. The inscriptions "1839 / MS" are followed by the embroidered names and birth (?) dates of the Schyfer family members. 57.117

182. *Family Record,* Lorenza Fisk. Concord-Lexington area, Massachusetts, probably 1811. Silk on linen; satin whip, tent, flat, cross, and chain stitches; H. 48.9 cm, W. 41.91 cm. A family tree with names and birth dates worked into the ten apples hanging from branches. The parents names are at the base of the tree. See Fig. 29. 69.430, gift of Mrs. Alfred C. Harrison

183. Memorial, Fanny Whitney. Portland, Maine. Watercolor, ink and graphite on wove paper; H. 50.3 cm, W. 62.3 cm. The neoclassical tomb is inscribed "Sacred / TO THE MEMORY OF / FIVE INFANTS." The "infants" may have been her siblings, but mourning pictures (both needlework and watercolor) were popular projects for accomplished young ladies and often did not reflect any personal mourning or sense of grief. 60.327.4

184. Cutwork picture, America, 1850-70. Ink, graphite, silk, wool, hair, string, copper foil on wove rag paper; H. 25.5 cm, W. 37.7 cm. Three rows of cut out figures. Each corner has a different initial: H, S, M, L. 65.2038

185. Needlework picture of a family scene, Chester County, Pennsylvania, 1815-35. Silk, paint; whip and satin stitches; H. 13.9 cm, W. 24.8 cm. 64.1639

186. Portrait of a family, attributed to Jacob Maentel. Pennsylvania, possibly Lebanon County, 1830-40. Watercolor

on wove rag paper; H. 44.6 cm, W. 55.8 cm. See Fig. 55. 57.1123

187. LANDING OF LAFAYETTE AT NEW YORK, America, post 1824. Oil on canvas; H. 44.2 cm, W. 59.7. A copy of an 1824 engraving by Samuel Maverick. 59.1127

188. *Newyork*, New York, 1780-1805. Watercolor and ink on paper; H. 26.2 cm, W. 36.8 cm, by sight. Using an existing print of New York from Brooklyn, the copyist took artistic license and emphasized the steeples and the boat construction. The buildings in the foreground are also updated. 57.1147

189. Blanket chest with drawers, upper Berks County, Pennsylvania, 1765-1810. White pine, painted decoration; H. 70.5 cm, W. 128.9 cm. Press printed religious broadside pasted to lid. Drawing on broadside attributed to Georg Frederich Speyer, probably Berks or Dauphin (now Lebanon) County, Pennsylvania, 1785-1800. Watercolor and ink; H. 40.7 cm, W. 34 cm. See Fig. 61. 55.95.1,2

190. *Taufschein* of Lea Jacky, by Abraham Huth. North Lebanon Township, Lebanon County, Pennsylvania, 1821-27. Watercolor and ink Fraktur; H. 32.2 cm, W. 39.35 cm, by sight. Signed "Gemold und zu haben beÿ: Abraham Huth / Libanon Taunschip Libanon Cauntÿ Kümmerlings Schulhaus." Decorated with stylized flowers, including tall tulips, and small cherubim. 52.84

191. Printed *Taufschein* for Johannes Bender, attributed to Heinrich Otto. Near Ephrata, Pennsylvania, dated 1784. Press printed in three colors of ink, block printing and freehand decoration added later; H. 34 cm, W. 42.1 cm. See Fig. 44. 58.120.17

192. *Taufschein* of Johannes Machemer, attributed to the Reverend Henry Young. Turbot Township, Northumberland County, Pennsylvania, 1827-40. Watercolor and ink Fraktur; H. 31.1 cm, W. 20.4 cm. See Fig. 42. 58.120.20

193. *Familien Tafel* ("family record") for Georg and Maria Albert Jacob, by Ludwig Crecelius. Probably Berks County, Pennsylvania, ca. 1830. Watercolor and ink Fraktur; H. 48.3 cm, W. 36.2 cm. Family registers are rare in Pennsylvania-German Fraktur. 57.1210

194. Cutwork *Taufschein* of William D. Hoffman, Colebrookdale Township, Berks County, Pennsylvania, 1825-40. Watercolor and ink Fraktur on wove rag paper; H. 17.5 cm, W. 27 cm. The paper was folded into quarters when the design was cut. See cover. 53.150.2

195. *Taufschein* of Samuel Hachmeister, by Francis Portzline. Chapman Township, Union County, Pennsylvania, 1845-55. Watercolor and ink Fraktur on wove rag paper; H. 38.8 cm, W. 31.3 cm. Signed "Francis Portzline" at the bottom. See Fig. 78. 65.602

196. Plate, attributed to Absalom Bixler. Possibly Berks County, Pennsylvania, ca. 1826. Red earthenware, impressed and slip decorations; Diam. 35.9 cm. "1732. INDEPENDENCE. HALL. 1741. E. WOOLEY" is impressed in type letters around rim. Although begun in 1731, Carpenters Hall (Independence Hall) was largely constructed in 1741. Edmund Wooley was chief carpenter on the project. 67.1662

TOYS

197. Whirligig, America, 1825-1900. White pine, painted; H. 31.5 cm. 64.866

198. Jointed snake, America, 1850-1900. Linden, cord, glass beads, painted; L. 74.0 cm. See Fig. 52. 61.1147

199. Jointed figure, America, 1860-1930. Sheet iron, iron wire, brass, white pine, painted; H. 78.7 cm, W. 17.8 cm. See Fig. 54. 64.870

200. Acrobats, northeastern America, 1800-1900. White pine, painted iron wire; H. 37.1 cm, W. 39.4 cm. 64.868

201. Horse, America, Carlisle, Pennsylvania, ca. 1840. Tulip, painted; H. 32.2 cm, L. 32 cm. See Fig. 43. 60.709

202. Box with dominoes, America, 1775-1825. Mahogany box, ivory dominoes; L. 14.5 cm, W. 6.5 cm. 59.855

203. Miniature furniture, Pennsylvania, 1803. Red earthenware, incised decoration, clear lead glaze; dresser, H. 7.5 cm, W. 7 cm. Inscribed: "s.j. / j.w. / 1803" on cradle, "Sophia Jacob / 1803," on dresser and "s.j." on chest. See Fig. 5. 64.1720.1-.6

204. Box with two birds, Absalom Bixler, Denver, Pennsylvania, 1878. Tulip, painted; H. 10.7 cm, W. 10.7 cm. Inside bears label of Bixler who is probably not the Bixler who was a potter. 64.2019

205. Box with snake, rat, and bird, attributed to Absalom Bixler. Denver, Pennsylvania, ca. 1878. Tulip, painted; H. 8.5 cm, W. 8 cm. Inscribed "DN" on inside. 64.2017

206. Whistle, probably Pennsylvania, 1825-50. Red earthenware, slip-trailed decoration, clear lead glaze; H. 6.3 cm, L. 13.3 cm. 59.2282

207. Whistle, probably Pennsylvania, 1821. Red earthenware, incised decoration, clear lead glaze; H. 8 cm. Incised "i.s. / 1821" on back of bird. See Fig. 45. 60.639

208. Lion, probably Pennsylvania, 1840-80. Red earthenware, stamped decoration, brown glaze; H. 16.2 cm, L. 16.2 cm. See Fig. 47. 59.2268

209. Toy cradle, James Spencer, New York City, 1828-61. Tinned sheet iron, painted; H. 8.9 cm, W. 8 cm. Label on footboard: "J. Spencer / Maker / New York." 70.70

210. Miniature pail, America, 1840-80. Tinned sheet iron, iron wire, painted; H. 7.9 cm, W. 7.9 cm. 59.2009

211. Bank, attributed to Richard C. Remmey. Philadelphia, 1859-1900. Gray stoneware, painted cobalt decoration, salt glaze; H. 19 cm. 59.1756

NON-FUNCTIONAL OBJECTS

212. Crane, America, 1850-75. Tinned sheet iron, white pine; H. 69.2. See Fig. 49. 65.1890

213. Birds in nest, America, 1850-1900. White pine; H. 19.1 cm, W. 17.1 cm. 65.1859

214. Birdtree, attributed to "Schtockschnitzler" Simmons. Berks County, Pennsylvania, 1870-1910. Yellow pine, painted; H. 34.5 cm, W. 9 cm. Simmons was an itinerant carver who bartered his work for room and board. "Schtockschnitzler" translates as "cane carver." 67.745

215. Rooster, attributed to Wilhelm Schimmel. Cumberland Valley, Pennsylvania, 1865-90. White pine; H. 22.2 cm, W. 6.3 cm. 65.1857

216. Bird, attributed to "Schtock-schnitzler" Simmons. Berks County, Pennsylvania, 1870-1910. Poplar, painted; H. 19 cm, W. 19 cm. 67.744

217. Owl, America, 1850-1900. Birch; H. 26.6 cm. See Fig. 36. 59.1501

218. Eagle, attributed to Wilhelm Schimmel or Aaron Mountz. Cumberland County, Pennsylvania, 1865-1949. Linden, painted; H. 75 cm, W. 89 cm. See Fig. 35. 59.2350

219. Man on dog, America, 1860-1900. Red earthenware, brown glaze; H. 23.6 cm, W. 9.2 cm. Sewer-pipe pottery workers occasionally fashioned such articles for their own enjoyment. See Fig. 99. 67.1885

220. Goat, probably Pennsylvania, 1830-80. Buff earthenware, stamped decoration, clear lead glaze; H. 11.7 cm. 59.2214

221. Hanging plaque or sign, possibly Pennsylvania, ca. 1850. Red earthenware, stamped decoration, mottled lead glaze; H. 41.2 cm. W. 26.7 cm. See Pl. V. 59.2294

222. Monkey with fiddle, attributed to Milton Hoopes pottery. Downingtown, Pennsylvania, 1842-64. Red earthenware, stamped and incised decoration, brown glaze; H. 21.4 cm, W. 6.4 cm. See Fig. 53. 59.2269

223. Monkey with bottle, attributed to Milton Hoopes pottery. Downingtown, Pennsylvania, 1842-64. Red earthenware, stamped and incised decoration, brown glaze; H. 20 cm, W. 8.4 cm. See Fig. 53. 59.2279

224. Fraktur, eastern Pennsylvania, possibly York, 1800-1820. Watercolor and ink on paper; H. 32.6 cm, W. 39.7 cm. 58.120.12

225. Fraktur, attributed to Georg Frederick Speyer. Probably Berks or Dauphin (now Lebanon) County, Pennsylvania, 1785-1800. Watercolor and ink on paper; H. 42.9 cm, W. 38.7 cm. The repetition of the figures and the unusually careful drawing suggests that this was a sketch sheet. 61.43

ANNOTATED BIBLIOGRAPHY

The items included in this selective bibliography have been chosen from the vast body of anecdotal and aesthetic literature on American folk art for their particular relevance to the objects from the Winterthur Collection displayed in the exhibition. Entries are grouped by object type or medium.

GENERAL AND METHODOLOGICAL STUDIES

Christensen, Erwin O. *The Index of American Design.* New York: Macmillan Co., 1950. A summary guide to the over 17,000 watercolor illustrations in the index compiled by artists employed by the federal government between 1935-41. The index created a new interest in American folk art.

Dorson, Richard M., ed. *Folklore and Folklife: An Introduction.* Chicago: University of Chicago Press, 1972. See especially Warren E. Roberts on folk crafts and Henry Glassie on folk art.

Glassie, Henry. *Pattern in the Material Folk Culture of the Eastern United States.* Philadelphia: University of Pennsylvania Press, 1969. Glassie employs the method of the cultural geographer. His bibliography is the best available on folk crafts.

Jones, Michael Owen. *The Hand Made Object and Its Maker.* Berkeley and Los Angeles: University of California Press, 1975. Jones questions the current assumptions about style, periodicity, cultural evolution, and diffusion.

Riedl, Norbert F. "Folklore and the Study of Material Aspects of Folk Culture." *Journal of American Folklore* 79 (1966): 557-63. Riedl calls for a broader interpretation of "folklore" and suggests moving toward the "folklife" model of European studies: folk culture is the unconscious, unreflective, traditional part of culture distinct from the totality of man's learned behavior yet an integral part of the lifeway of a people.

FURNITURE AND WOODENWARES

Fales, Dean A., Jr. *American Painted Furniture: 1660-1880.* New York: E. P. Dutton & Co., 1972. Chronological survey of the development of decoration.

127

Fraser, Esther Stevens. "Pennsylvania Bride Boxes and Dower Chests." *Antiques* 8 (1925): 20-23, 79-84. Survey of decorated chests illustrated with examples from several counties; basis for most later discussions.

Hopf, Carroll J. "Decorated Folk Furniture." *Pennsylvania Folklife* 20 (1970-71): 2-8. Identifies historical material culture as wood-oriented; discusses paints and pigment sources used to ornament furniture whose style is based on local cultural environmental precedents rather than on current stylish vogues.

Morse, John D., ed. *Country Cabinetwork and Simple City Furniture.* Charlottesville: University Press of Virginia, 1970. See the contributions of Charles S. Parsons and Bruce R. Buckley.

Parsons, Charles S. "The Dunlap Cabinetmakers." In *The Dunlaps & Their Furniture.* Manchester, N.H.: Currier Gallery of Art, 1970. Expands a 1969 Winterthur Conference paper and incorporates the catalogue of the 1970 Currier exhibition of Dunlap furniture.

Trent, Robert F. *Hearts & Crowns.* New Haven, Conn.: New Haven Colony Historical Society, 1977.

Weiser, Frederick S., and Mary Hammond Sullivan. "Decorated Furniture of the Mahantango Valley." *Antiques* 103 (1973): 932-39. Discussion of three groups of painted furniture from the Mahantango Valley of Pennsylvania, with identification of ornament sources and ownership histories.

METALWARES

Blood, Judith. "American Tin Toys at the Abby Aldrich Rockefeller Folk Art Collection." *Antiques* 110 (1976): 1300-1305. A useful index to the American toy trade.

DeVoe, Shirley Spaulding. *The Tinsmiths of Connecticut.* Middletown: Wesleyan University Press, 1968. Historical survey with discussion of decorative techniques and motif sources; includes appendices listing workers, women painters and japanners, and firms active in the tinware and related industries.

Kauffman, Henry J. *Early American Ironware: Cast and Wrought.* Rutland, Vt.: Charles E. Tuttle Co., 1966. A survey of techniques and products.

NEEDLEWORK AND TEXTILES

Bolton, Ethel Stanwood, and Eva Johnston Coe. *American Samplers.* 1921. Reprint. New York: Dover Publications, 1973. An early survey which includes a checklist of samplers, 1700-1830, alphabetically by makers, and an anthology of sampler verse.

Gehret, Ellen J., and Alan G. Keyser. Introduction to *The Homespun Textile Tradition of the Pennsylvania Germans.* Harrisburg: Pennsylvania Historical and Museum Commission, 1976. Authors define folk textiles and discuss production techniques and product usage in the home.

Nylander, Jane C. "Some Print Sources of New England Schoolgirl Art." *Antiques* 110 (1976): 292-301. New Information about design sources used by young women attending early nineteenth-century seminaries and academies, and relates these to the school curricula.

Orlofsky, Patsy and Myron. *Quilts in America.* New York: McGraw-Hill Book Co., 1974. From the collector's viewpoint; includes aid to dating quilts.

Roth, Rodris. "Floor Coverings in 18th-Century America." Paper 59 in *Contributions from the Museum of History and Technology.* United States National Museum Bulletin 250. Washington, D.C.: Smithsonian Institution, 1967. The basic text on American floorcovering.

Swan, Susan Burrows. *Plain and Fancy: American Women and Their Needlework.* New York: Holt, Rinehart & Winston Co., 1977, and *A Winterthur Guide to American Needlework.* New York: Crown Publishers, 1976. The two volumes above discuss major needlework techniques and the stitches used to execute them. The first includes an extensive glossary of period needlework terms.

CERAMICS

Barber, Edwin Atlee. *The Pottery and Porcelain of the United States and Marks of American Potters.* 1909. Reprint, 3d ed. New York: Feingold & Lewis, 1976. A combination of the definitive work on ceramics production in America and a survey of makers.

Bivins, John, Jr. *The Moravian Potters in North Carolina.* Chapel Hill: University of North Carolina Press, 1972. Correlates archaeological finds with records and existing pieces of pottery. Includes biographical information on craftsmen and glossaries of ceramics and Moravian terms.

James, Arthur E. *The Potters and Potteries of Chester County, Pennsylvania*. West Chester: Chester County Historical Society, 1945. Helpful alphabetically arranged discussion of various potters, with chart of interrelationships and apprenticeships.

Watkins, Lura Woodside. *Early New England Potters and Their Wares*. 1950. Reprint. Hamden, Conn.: Shoe String Press, Archeon Books, 1968. Somewhat dated but sound; includes a checklist of potters.

Webster, Donald Blake. *Decorated Stoneware Pottery of North America*. Rutland, Vt.: Charles E. Tuttle Co., 1971. A pictorial survey organized by subject categories of decoration. Appendix includes checklist of potteries.

Wiltshire, William E., III. *Folk Pottery of the Shenandoah Valley*. New York: E. P. Dutton & Co., 1975.

PAINTING AND DRAWING

Black, Mary C., and Jean Lipman. *American Folk Painting*. New York: Bramhall House, 1966. A chronological and stylistic survey of folk art and artists in terms of their roles in their communities and in light of modern appraisals of their works.

Little, Nina Fletcher. *American Decorative Wall Painting 1700-1851*. New York: E. P. Dutton & Co., 1972. The standard study.

Mather, Eleanore P. "A Quaker Icon: The Inner Kingdom of Edward Hicks." *Art Quarterly* 36 (1973): 84-99. Relates the shifting iconography of Hicks's *Peaceable Kingdoms* to the doctrinal transitions occurring within the Quaker faith and within Hicks's own beliefs.

Stebbins, Theodore E. *American Master Drawings and Watercolors*. New York: Harper & Row, 1976. See especially Chapter 5, "Folk and Country Drawings."

FRAKTUR

Evans, Nancy Goyne. "Documented Fraktur in the Winterthur Collection." *Antiques* 103 (1973): 307-18, 539-49.

Leeds, Wendy. "Fraktur: An Annotated Bibliography." *Pennsylvania Folklife* 25 (1976): 35-46. A useful bibliography.

Shelley, Donald A. *The Fraktur-Writings or Illuminated Manuscripts of the Pennsylvania Germans.* Allentown: Pennsylvania German Folklore Society, 1961. Takes an art-historical approach, classifying examples by "schools" based on artistic style; includes an extensive bibliography on folk art in general.

Weiser, Frederick S., and Howell J. Heaney, comps. *The Pennsylvania German Fraktur of the Free Library of Philadelphia.* 2 vols. Breinigsville, Pa.: Pennsylvania German Society and The Free Library of Philadelphia, 1976.

Weiser, Frederick S. "Piety and Protocol in Folk Art: Pennsylvania German Fraktur Birth and Baptismal Certificates." In *Winterthur Portfolio 8,* edited by Ian M. G. Quimby, pp. 19-43. Charlottesville: University Press of Virginia, 1973. Counters Shelley's approach.

Yoder, Don, Vernon S. Gunnion, and Carroll J. Hopf. *Pennsylvania German Fraktur and Color Drawings.* Lancaster: Landis Valley Associates, 1969. Yoder claims that vorschriften texts provide the most direct clues on the meaning of fraktur in the culture which produced it.

SCULPTURE

Armstrong, Tom. "The Innocent Eye: American Folk Sculpture." In *200 Years of American Sculpture,* pp. 77-111. New York: David R. Godine, in association with the Whitney Museum of American Art, 1976. Art historian Armstrong defines folk sculpture by opposing it to American academic sculpture of the same periods and finds a basic expression of the American people.

Barbeau, Marius. "All Hands Aboard Scrimshawing." *American Neptune* 12 (1952): 3-26. A good survey peppered with contemporary whalers' references to scrimshawing.

Grancsay, Stephen V. *American Engraved Powder Horns: A Study Based on the J. H. Grenville Gilbert Collection.* 1946. Reprint. Philadelphia: Ray Riling Arms Books, 1965. Essay precedes the catalogue of the collection; a checklist records powder horns in four categories—owners, dated, map-horns, miscellaneous.

Kaye, Myrna. *Yankee Weathervanes.* New York: E. P. Dutton & Co., 1975. Approaches the weathervane as a democratic art form; employs drawings instead of photographs to document examples; appendix lists American weathervane makers and vendors.

Photographs by George Fistrovich

Printing by Lebanon Valley Offset Company

Design by John Anderson